IMAGES
of America

DURHAM COUNTY

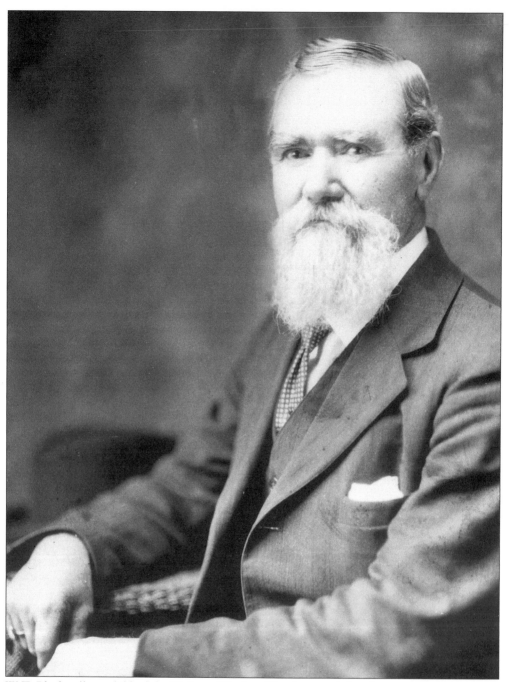

W.T. Blackwell was dubbed the "father of Durham" by the town's first historian, Hiram Paul, in 1884. A partner with Julian Carr and John R. Green in the production and sale of Bull Durham tobacco, Blackwell—Paul wrote—"proved himself eminently capable and worthy in every sense of conducting the then infant enterprise to a success surpassing anything in the annals of the history of Tobacco." Leaving the tobacco business to go into banking, however, Blackwell died impoverished, relying for support in his later life upon the generosity of his former tobacco competitor, Ben Duke. (Courtesy Durham County Public Library.)

2

IMAGES
of America

DURHAM COUNTY

Jim Wise

With best hopes,

Jim Wise

ARCADIA

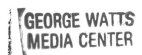

Published by Arcadia Publishing,
an imprint of Tempus Publishing, Inc.
2 Cumberland Street
Charleston, SC 29401

Printed in Great Britain.

Library of Congress Catalog Card Number: 00-107419

For all general information contact Arcadia Publishing at:
Telephone 843-853-2070
Fax 843-853-0044
E-Mail sales@arcadiapublishing.com

For customer service and orders:
Toll-Free 1-888-313-BOOK

Visit us on the internet at http://www.arcadiapublishing.com

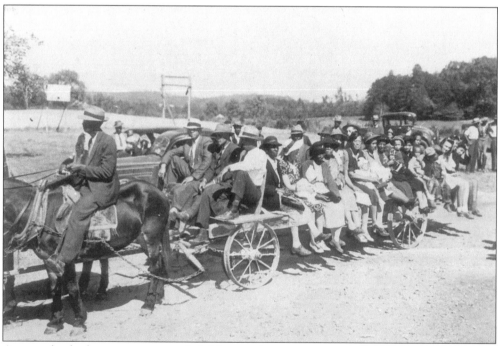

A wagonload of men, women, and children arrives at a country-church picnic in northern Durham County around 1940. The picnic's theme was for people to arrive via unusual means of transportation. (Courtesy Duke University Manuscript Collection.)

CONTENTS

Bahama took its name from three prominent local families—Ball, Harris, and Mangum. The community's earlier name, "Hunkadora," seemed rather silly when the Lynchburg & Durham Railroad established its station there in 1890.

ACKNOWLEDGMENTS

For aid and comfort, for encouragement, advice, assistance and, most of all, patience, the author wishes to thank John Ansley of the Durham County Public Library; Dale Coats and Jennifer Farley of Duke Homestead State Historic Site; Juliana Hoekstra and Kathleen Needham of Historic Stagville; Beth Highley of West Point on the Eno Park; Jon Ham, Bill Hawkins, Harold Moore, and Janet Sammons of the *Durham Herald-Sun*; Milo Pyne; Curtis Booker; Mary Bell; Elizabeth Moorman; Alice Eley Jones; and the cheerfully helpful folks at CCI Photographics and Duke Medical Photography. And most especially, Babs, Elizabeth, and Ben.

This book is dedicated to Wade Ring.

INTRODUCTION

Created in 1881 from the eastern part of Orange County and a bit of Wake, Durham is a modest-sized county, as North Carolina counties go. It spreads over 296 square miles, from sandy, marshy lowlands in places reminiscent of the coastal plain at its south, to rolling hills in places reminiscent of the mountains at its north.

Geography, however, is not the difference between south and north that makes the first and foremost impression. Southern Durham, especially near the Interstate 40-NC 54 highway corridor linking the Research Triangle Park and Raleigh-Durham International Airport with Chapel Hill to the west and Raleigh, the state capital, to the east, is a textbook case of modern urban sprawl. Northern Durham, on quite the other hand, remains farm country, with horse pastures, quiet crossroads communities, scenic byways and, even today, fields of tobacco.

For most practical, and some arguably impractical, purposes, though, Durham County is a citified place. The county's population is about 220,000; three-quarters of those reside in the city of Durham, the only incorporated town. The greater Triangle area, made up of Durham, Raleigh, and Chapel Hill (with their respective institutions Duke University, University of North Carolina, and North Carolina State University) and several neighboring towns, has a population of 1 million, with 700,000 additional residents expected by 2025. The growth of the town as an economic and population center was the reason for the creation of the county.

Europeans began moving into the area around 1750, taking over lands that had been largely deserted by a native population recorded by the explorers John Lederer in 1660 and John Lawson in 1701. Settlers took root on small farms, primarily in the northern part of present Durham County, where bottomlands along the Flat, Little, and Eno Rivers provided fertile grounds and an old Native-American trading path afforded connection with well-settled Virginia to the north, and south to the county seat of Hillsborough and beyond as far as the Savannah River.

Early commerce took the form of gristmills along the three rivers and New Hope Creek in the south and, here and there, trading posts. Richard Bennehan, a settler who came down from Virginia around 1770, turned his country store into an empire. Starting with part interest in a store on the Little River, Bennehan later opened another store at a place called Stagville, the site of an old inn. Taking his profits, Bennehan expanded into moneylending, commodities brokering, auctions, horsebreeding, and a post office. He also bought land and slaves. In 1803 he created a business with his son Thomas and his son-in-law, prominent lawyer Duncan Cameron, which grew to include, by the outbreak of the War between the States in 1861, about 30,000 acres, 900 slaves, mills, stores, and various other enterprises.

Richard Bennehan's modest home at Stagville, built about 1787 and enlarged in 1799, is now a state-owned historic site; visitors are often surprised to find a Southern plantation house lacking both columns and veranda. Almost as modest is the Duke Homestead, where Washington Duke, in 1865, began the tobacco business that grew into the American Tobacco

trust and spun off textile and hydroelectric companies, a railroad, and Duke University. Duke's farm lay about 3 miles from the village of Durham's Station, established on the North Carolina Railroad in 1853. About the time he was starting his enterprise, business was starting to boom at the station with orders for the local brightleaf tobacco—the qualities of which had been discovered and appreciated by soldiers who raided a nearby warehouse during surrender negotiations between Union general W.T. Sherman and Confederate general Joseph Johnston at the James Bennitt farm in April 1865.

The town of Durham grew, with commerce, from 100 people in 1860 to more than 2,000 by 1880. Travel to Hillsborough to conduct business was increasingly troublesome for Durham's entrepreneurs, who began pressing the case for·a county of their own. It came into being on February 28, 1881.

Growth continued rapidly. The city population had reached 18,000 by 1910, as rural populations left uncertain life on the farm for the security of regular pay and the amenities a town offered. Town and country populations were about equal in Durham County by 1920; over the next ten years, the country's share dropped to 22.6 percent of a total 67,000 people.

Unlike the long-established nearby towns such as Hillsborough, Chapel Hill, and Raleigh, Durham began fresh after the Civil War. The new, fast-growing town offered opportunity for black residents as well as white. A black section that came to be called "Hayti" grew up across the railroad from the main part of town; most of its pioneer landowners were former slaves of the Bennehan-Cameron plantation. Enterprising African Americans, just like their white counterparts, began making money as carpenters, blacksmiths, barbers, morticians—then expanded into real estate and finance.

In 1898, the N.C. Mutual and Provident Society was founded. Renamed N.C. Mutual Life Insurance, the company would become the largest black-owned financial institution in the world. In 1906, it built a headquarters on property one of its founders, John Merrick, had bought in the heart of Durham's business district. The Mutual grew and began other businesses: a bank, a newspaper, a real-estate firm, a textile mill, and so on, earning Parrish Street the nickname the "Black Wall Street of America."

A college for blacks, the National Religious Training School and Chatauqua, opened in 1910; it is now North Carolina Central University, part of the state university system. Across town, Trinity College had moved from rural Randolph County to a fairground in 1892. Patronized heavily by the Duke family and other Durham tycoons, Trinity became the prime beneficiary of the Duke Endowment, created in 1924. The school changed its name to Duke University, rebuilt its old campus, and added an entirely new one on a pine-wooded hill a mile west.

The tobacco industry generally insulated Durham from the Depression. World War II brought thousands of GIs to town, taking rest and rehab from training at nearby Camp Butner, while the American and Liggett & Myers plants produced 25 percent of the nation's cigarettes. In the late 1950s, Durham, Raleigh, and Chapel Hill interests came together to create the Research Triangle Park, the engine of an economic boom that has accelerated even as Durham's older industries, textiles and tobacco, closed up their shops and moved away. A Durham plant will have rolled its last cigarette before the end of 2000.

Constant transition, then, if not quite "perpetual revolution" (the title of a student speaker's address at Duke graduation in the tumultuous spring of 1970), is a fact of Durham life. It is also the theme of this book.

One

THENS,
THENS AND NOWS

Over the years, the built landscape of Durham County has changed—and frequently changed again. One of the most dramatic cases was the building of a grand downtown hotel in 1924 and 1925—and its destruction, in 8 seconds, one Sunday morning 50 years later. On another hand, some spots—and the uses people put them to—have changed hardly at all, and others have been made over to suit the ever-changing times.

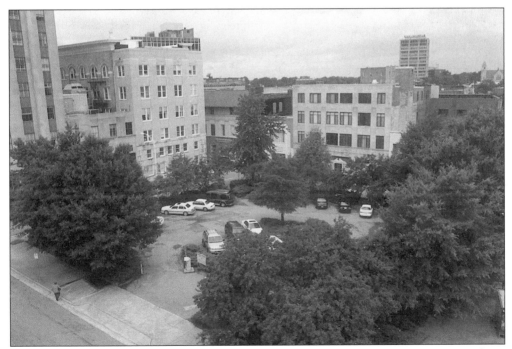

Bare Square, a parking lot at the heart of downtown Durham, was once the site of the Academy of Music, a Neoclassical Revival building that housed a meat market and city offices along with an auditorium. In the 1920s, the Academy was demolished to make way for the Washington Duke Hotel which, in its own time, had to go as well.

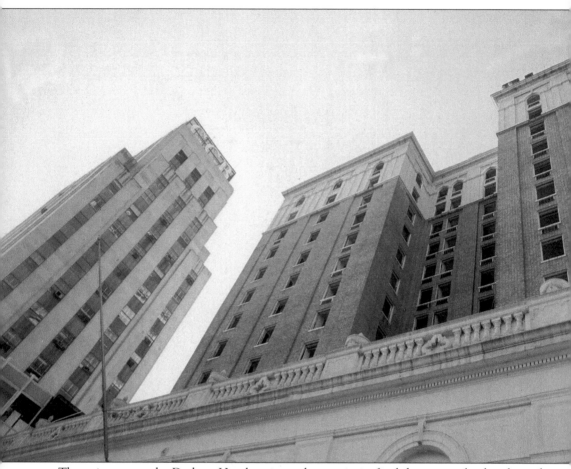

The twin towers: the Durham Hotel, as it was known in its final days, was a landmark on the city skyline, along with the Hill Building, the home of Central Carolina Bank. The Hill Building was designed in the 1930s by the Shreve, Lamb and Harmon architectural firm that had already drawn up the Empire State Building of New York City. (Courtesy Frank DePasquale.)

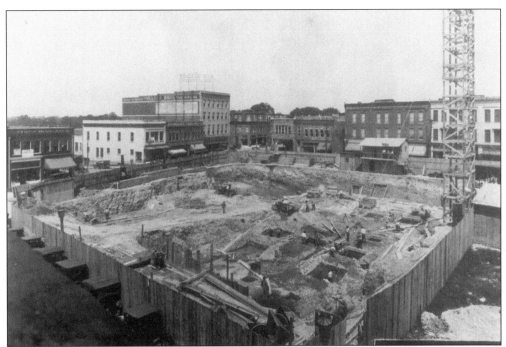

In its time, the hotel was a mark of a town that had arrived. City offices moved to the old Durham High School building on Morris Street, and a new Durham Auditorium—better known as the Carolina Theatre—took over from the Academy of Music. In the above photograph, construction begins in July of 1924; the image below, taken on October 29 of that same year, shows considerable progress. (Both images courtesy Durham County Public Library.)

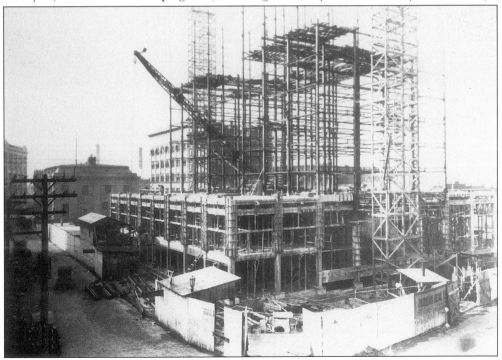

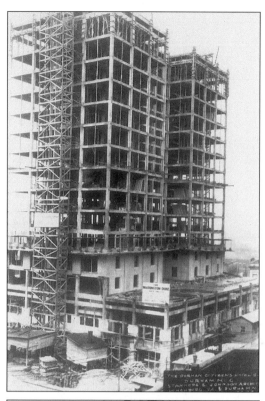

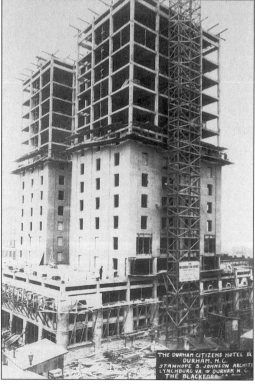

The Durham Hotel goes up, in the spring of 1925 (top left) and in May 1925 (bottom left). (Both images courtesy Durham County Public Library.)

The Washington Duke, later the Jack Tar, later the Durham Hotel, was the fashionable address in Durham for 50 years, the site of civic club meetings, class reunions, fraternity formals, and all manner of such occasions of note. The author even remembers watching Lyndon Johnson's abdication speech, on March 31, 1968, in the hotel's downstairs bar. (Courtesy Durham County Public Library.)

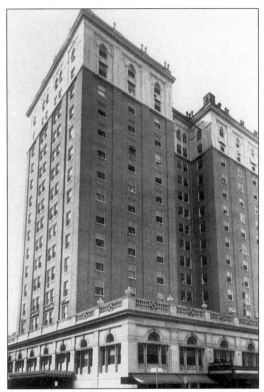

Architect Frank DePasquale stationed himself on top of another downtown building on Sunday morning, December 14, 1975, to capture the fall of the Durham Hotel. Declining revenues, high taxes, and inadequate air conditioning had turned the downtown landmark into an unprofitable proposition. (Courtesy Frank DePasquale.)

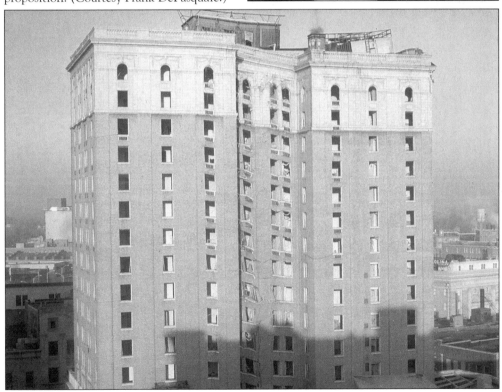

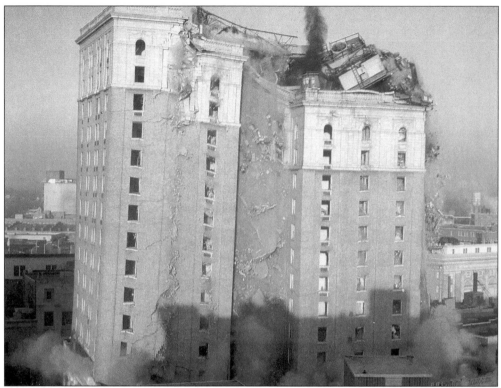

The Durham Hotel comes down, December 14, 1975, 8:00:01 a.m. (above) and 8:00:03 (below). (Both images courtesy Frank DePasquale.)

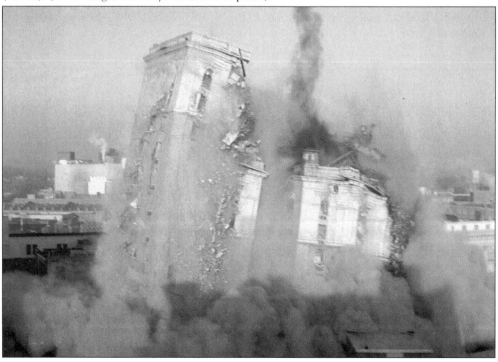

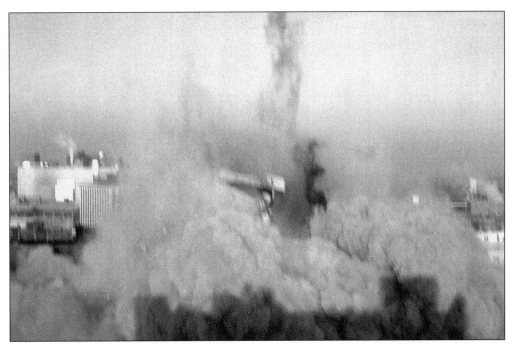

Coming down, December 14, 1975, 8:00:05 a.m. (Courtesy Frank DePasquale.)

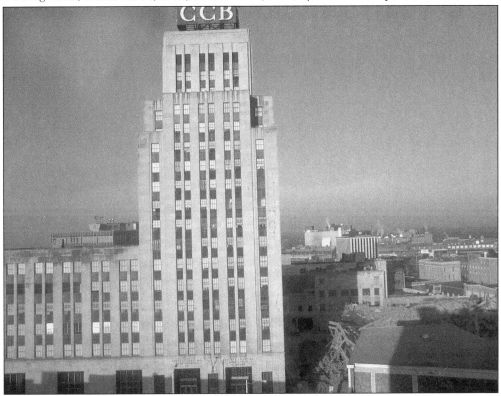

December 14, 1975, after the dust had cleared. The hotel's collapse took all of 8 seconds. (Courtesy Frank DePasquale.)

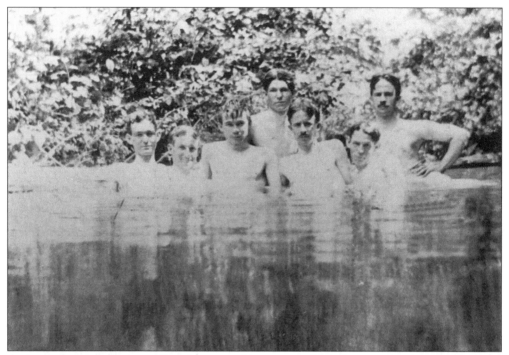

A group of gents enjoys a cooling dip in an old swimming hole during a Sunday school picnic, around 1920. (Courtesy Durham County Public Library.)

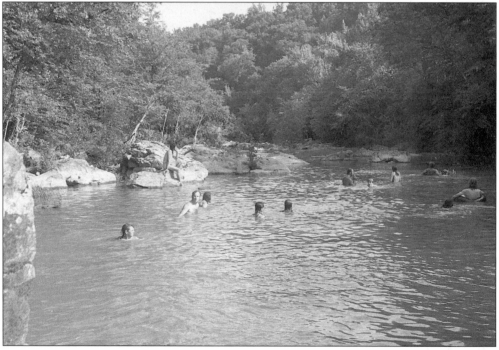

A group of men and women enjoys a cooling dip in the Little River, off Johnson's Mill Road, in 1974. This was a popular swimming hole for many years, until a 1981 murder cast something of a pall over the spot. The old path from the road down to the water no longer exists.

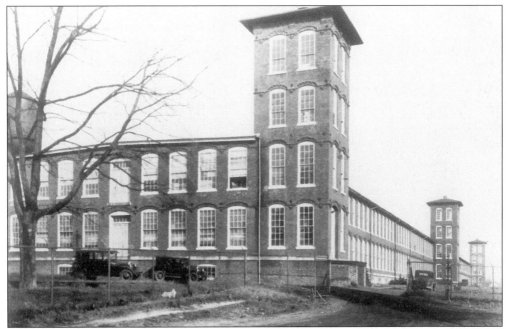

The Dukes diversified their business in the early 1890s, branching from tobacco into textiles. Erwin Mills became the focal point of West Durham, a factory community that grew to a population of 5,000. Manager William Erwin built churches, parks, schools, and an auditorium for his employees. (Courtesy Durham County Public Library.)

Erwin Mills was remodeled in the 1980s to accommodate offices in one of Durham's trendiest areas. The old mill village's business district along Ninth Street became a main street for the college community, with gourmet restaurants, music shops, and a bookstore sharing "mom and pop" space with pharmaceuticals and seed.

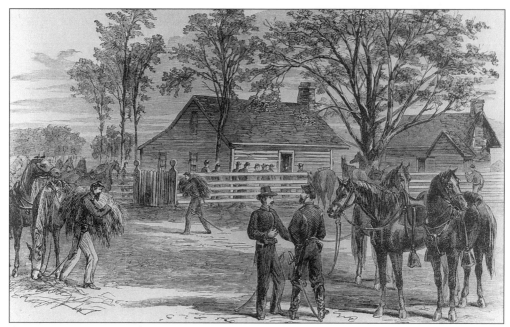

A magazine engraving depicts Union troops at Bennett Place, where Confederate general Joseph Johnston surrendered to Union general W.T. Sherman on April 26, 1865, ending the War between the States in the Carolinas, Georgia, and Florida. Soldiers idled during the generals' talks raided John R. Green's warehouse at Durham's Station and took a liking to the brightleaf tobacco stored there. Green at first thought he was ruined, but once the soldiers went home they sent a flood of requests for more of that good Durham tobacco, turning a seeming calamity into a Bull City. (Courtesy N.C. Division of Archives & History.)

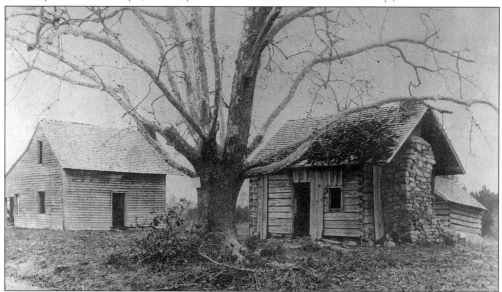

The Bennett property fell into disrepair as the 1800s went on. Hiram Paul, Durham's first historian, included an eyewitness account of the surrender talks in his 1884 *History of the Town of Durham, N.C.*, but even by then the old place was falling down. (Courtesy N.C. Division of Archives & History.)

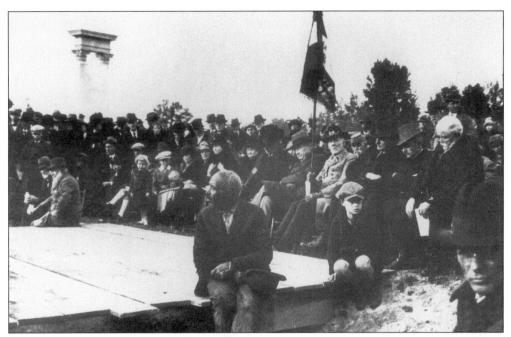

An unidentified black man sits amid a gathering of Confederate veterans and other interested citizens at the dedication ceremony for the Unity monument at Bennett Place, Nov. 8, 1923. The modest farmhouse of James Bennitt (why and when the spelling changed is unknown) was the site of negotiations between Union general W.T. Sherman and Confederate general Joseph Johnson in April 1865, which led to the largest surrender of Confederate troops at the end of the War between the States, two weeks after Robert E. Lee's surrender at Appomattox. (Courtesy Durham County Public Library.)

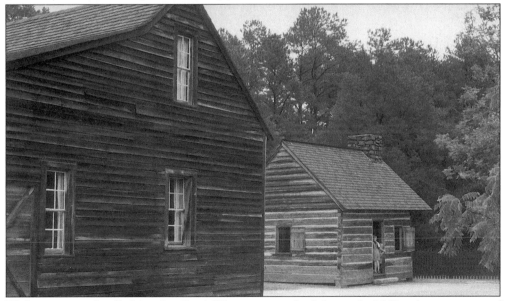

With interest rekindled by the Civil War centennial of the early 1960s, the structures of Bennett Place were rebuilt. It became a State Historic Site in 1978, and is the scene of an annual reenactment of the surrender talks and soldiers' encampment in April.

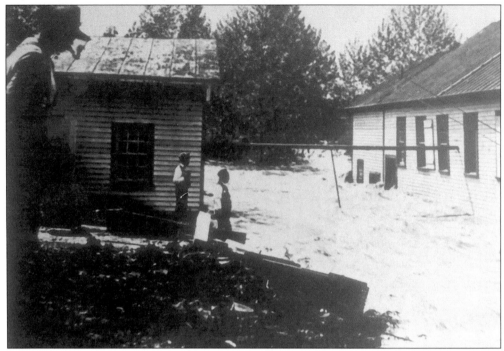

High water has been a danger that Durham County has had to deal with from early on. Here, citizens watch as the Eno River floods through a mill complex in 1898. (Courtesy Durham County Public Library.)

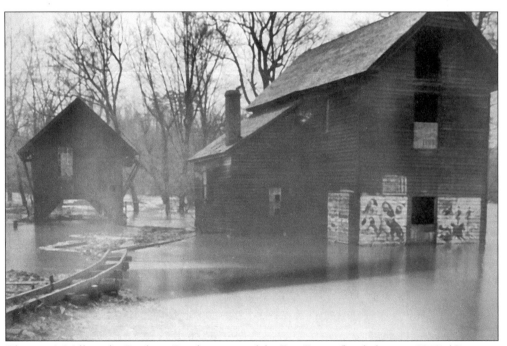

Christian's Mill, at the Roxboro Road crossing of the Eno River, flooded out in 1908. (Courtesy West Point on the Eno Park.)

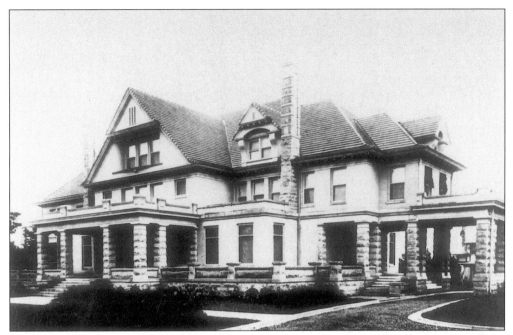

Four Acres, the home of philanthropist Benjamin Newton Duke, stood at the corner of Duke and Chapel Hill Streets near downtown Durham. Built in 1911 at a cost of $136,000, the home was given to Duke University in 1936 for use as a guesthouse and reception center.

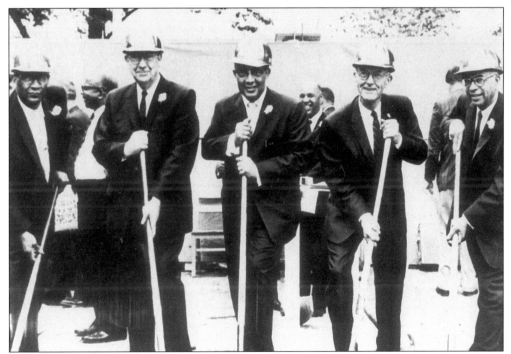

In 1960, Duke University sold the Four Acres property to the N.C. Mutual Life Insurance Co., the largest black-owned business in the United States. Mutual had the old house demolished and broke the ground for its new headquarters tower.

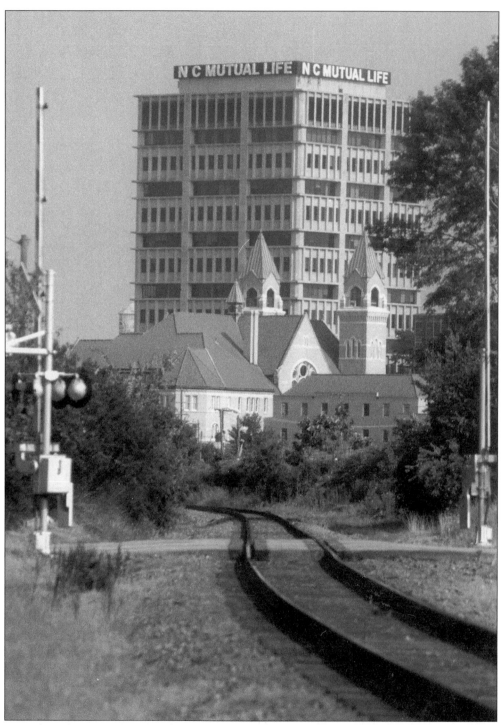

Nowadays, the N.C. Mutual building looms large on the Durham skyline. It stands catty-corner from the twin-towered Duke Memorial United Methodist Church, which began as a Sunday school in the Duke tobacco factory and occupies the former site of the residence of W.T. Blackwell—at one time, the Dukes' main competitor in the smoking tobacco business.

Two
BEGINNINGS

Durham County's story got its start with the land itself. Colonial explorers were impressed by the wealth of game and agricultural bounty enjoyed by the Eno and Occaneechee Indians, who once lived along the Eno River. European settlers cleared small farms, forming the basis for the first industry—gristmills. Some early farms grew into slave-tended plantations; others were seedbeds for the tobacco growing, processing, and marketing that would set off the county's ongoing economic and population booms.

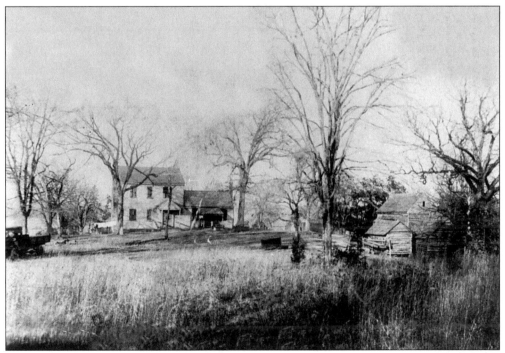

Visible in this c. 1918 view of Stagville, the Bennehan House, center background, was begun around 1787. From a modest farm, the Bennehan and Cameron families built an enormous antebellum enterprise, with 4,000 acres in North Carolina worked by 500 slaves, and other plantations in Alabama and Mississippi. Visitors are sometimes surprised to learn that a real Southern plantation house comes without Greek-Revival columns. (Courtesy Historic Stagville.)

Tobacco created Durham. The leaf so favored by Civil War soldiers led to a bullish enterprise after the war; money made from tobacco financed the city's subsidiary industries—hotels, churches, saloons—and went into second and third generations of commerce, textiles, and higher education. The city seal once included tobacco leaves; they have since been replaced with a politically correct set of stars, no doubt representing the constellation Taurus, the Bull.

What made Durham tobacco so tasty was an accident, the result of a high-heat curing process discovered by Thomas, pictured here, a slave on the Caswell County plantation of Abisha Slade. Thomas, the story goes, fell asleep while minding the curing fires one night. Suddenly waking, he saw the fire had gone out and quickly built it up again, creating a burst of heat that turned the tobacco leaves a shade of golden brown and imparted to them a distinctive, mellow flavor. (Courtesy Duke Homestead State Historic Site.)

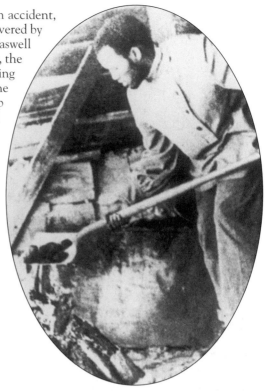

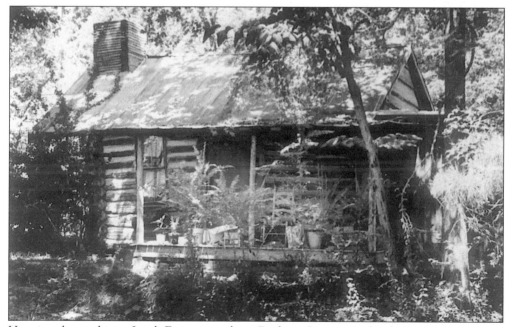

Here is a slave cabin at Leigh Farm in southern Durham County. Richard Leigh is the ancestor of perhaps 10,000 present residents of Durham and Orange Counties. His plantation, at the time of the War between the States, covered 500 acres and employed 14 slaves. (Brad Banks photograph, courtesy Curtis Booker.)

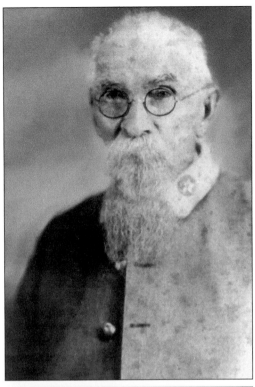

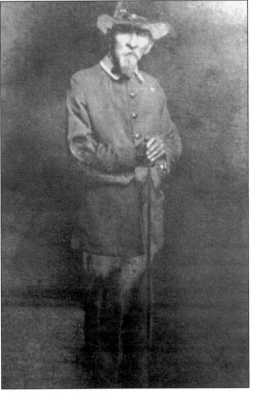

Thaddeus Redmond was the last
Confederate veteran in Durham County.
Before he died, in 1937, he shared
recollections about Dr. Bartlett Durham
with *Durham Sun* columnist Wyatt Dixon.
After the War between the States,
Redmond—an illegitimate son of pre-
Durham tavern keeper William
Pratt—became a member of the Ku Klux
Klan and late in life told a local reporter
of participating in the murder of two
black men. (Courtesy Durham County
Public Library.)

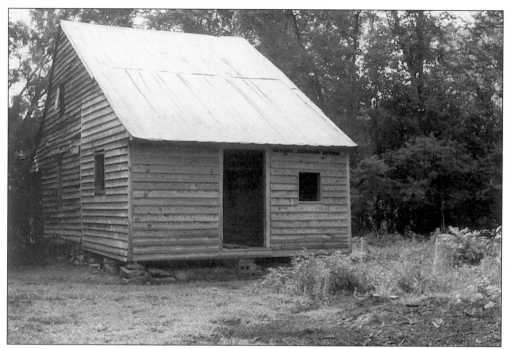

Thought to date from the 1770s, the Horton Cottage at Stagville, off the Old Oxford Highway, may be the oldest building in Durham County. The house was moved from its original location to serve as an overseer's residence at a slave community.

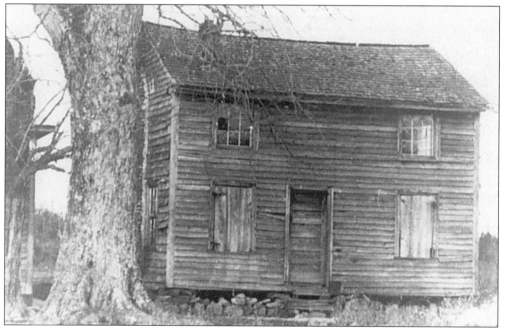

This is the birthplace of Washington Duke, the founder of the tobacco company that his son James B. would turn into an empire. This Duke home, which no longer exists, stood near the Little River in what is now northern Durham County. This photograph was made about 1930. (Courtesy Duke Homestead State Historic Site.)

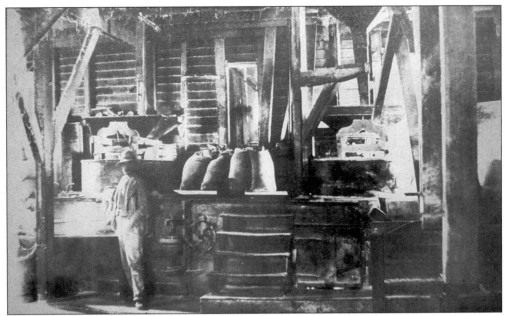

Here is an interior view of Christian's Mill, at the Eno River's intersection with the road from Durham's Station to Roxboro. Gristmills were an important early industry in what would become Durham County, creating communities and commerce along the Flat, Little, and Eno Rivers and New Hope Creek long before there was anything thought of as a town of Durham. (Courtesy West Point on the Eno Park.)

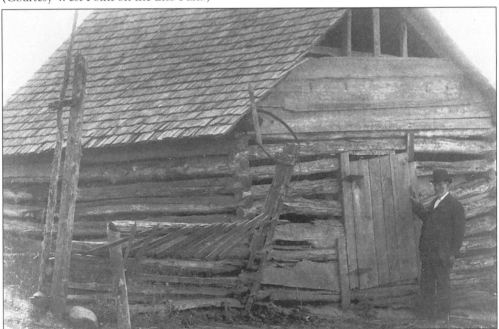

Washington Duke pauses outside one of his "factories" at the old homestead, now off Duke Homestead Road. Wash, who finished the War between the States as a prisoner of war, walked home from New Bern, and began a tobacco business in the fall of 1865. This photo was taken about 1904. (Courtesy Duke Homestead State Historic Site.)

John Taylor Duke was the father of Washington. (Courtesy Duke Homestead State Historic Site.)

Uncle Billie Duke, Wash's older brother, was a Methodist lay preacher and a builder of brush arbors. Uncle Billie was remembered for once praying for rain: "Lord, send us some rain. We need it. But don't let it be a gully-washer. Just give us a sizzle-sozzle." (Courtesy Duke University Archives.)

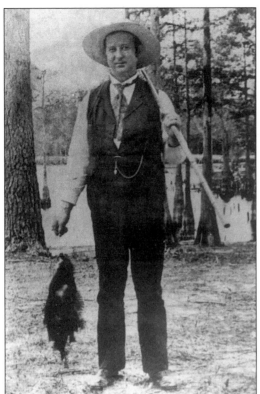

Even though he moved to New York City in 1884, James Buchanan Duke—better known as "Buck"—remained a good ol' boy at heart. This picture was made about 1890. (Courtesy N.C. Division of Archives & History.)

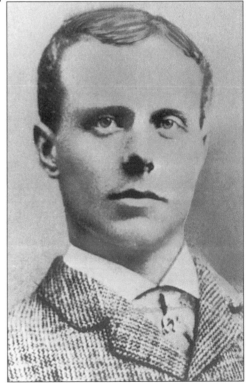

For all the local genius that went into promoting Durham tobacco and cigarettes, it was a Virginian, James Bonsack, who made the Duke empire happen. Bonsack invented a machine that could turn out 50 times as many cigarettes as the customary hand-rollers of the 1880s. James B. Duke's investment in Bonsack's machines, in 1884, was the trick that brought Duke a monopoly on the American cigarette business. (Courtesy Duke Homestead State Historic Site.)

Fairview, the Durham home of Washington Duke, stands at left with the original Duke tobacco factory at the right. This photograph was made about 1890, before Trinity College moved from Randolph County to the open space seen in the far background—then occupied by a racetrack and fairgrounds. (Courtesy Durham County Public Library.)

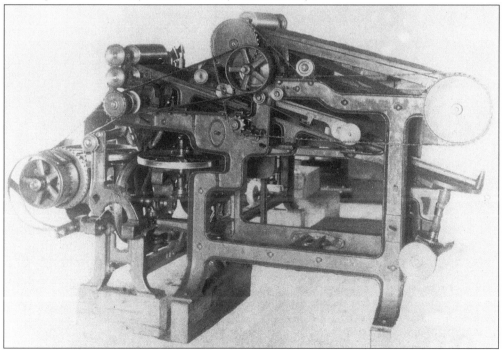

This is the original Bonsack machine. Automating a craft formerly dominated by dexterous Russian Jewish women, Bonsack's invention revolutionized the cigarette business and brought the Duke company total domination of the market in the 1880s. (Courtesy N.C. Division of Archives and History.)

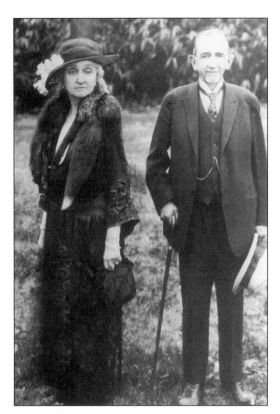

Sarah P. and Benjamin Duke are pictured here about 1930. Ben was the most interested in philanthropy of the Duke boys, and his wife helped cultivate literary tastes in Durham as an organizer of the Canterbury and Shakespeare clubs, along with some faculty members of Trinity College. (Courtesy Durham County Public Library.)

Brodie Duke, Washington's eldest son, was the black sheep of the family, gifted with a knack for real estate development along with a taste for high living. Developer of the now-gentrified Trinity Park neighborhood, Brodie was the first member of the Duke family to move from the old homeplace into the then-new town of Durham, in 1869. His warehouse, on Corporation Street at the old Belt Line railroad, is the oldest brick building in Durham. (Courtesy Duke Homestead State Historic Site.)

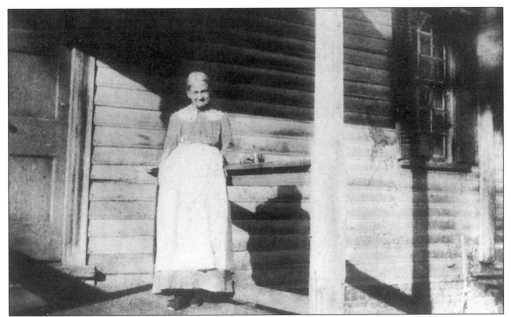

While industry boomed in the town of Durham, life went on in its accustomed rural ways in the rest of the county. The old Stagville place became a tenant farm. A Mrs. Ladd, posing here at the Bennehan House, helped run the place in the 1920s. (Courtesy Historic Stagville.)

The McCown-Mangum House at West Point on the Eno. At the time of the War between the States, the West Point gristmill was the centerpoint of a community of 300 families, with its own post office and a sawmill. The gristmill operated until 1942. The McCown-Mangum House is now office space and a museum for a city park that now occupies the site of the vanished village. (Courtesy West Point on the Eno Park.)

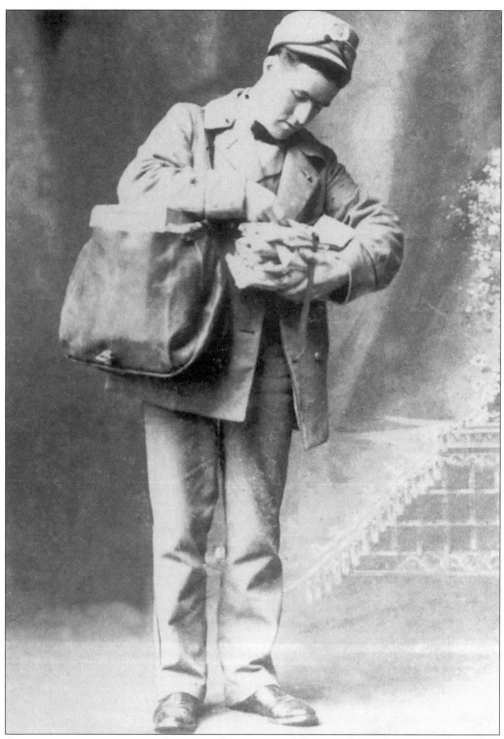

A growing community required certain public services. John L. Kirkland became Durham's first mail carrier in 1890, four years after he began his postal career. He carried the Bull City's mail until his retirement in 1936. (Courtesy Durham County Public Library.)

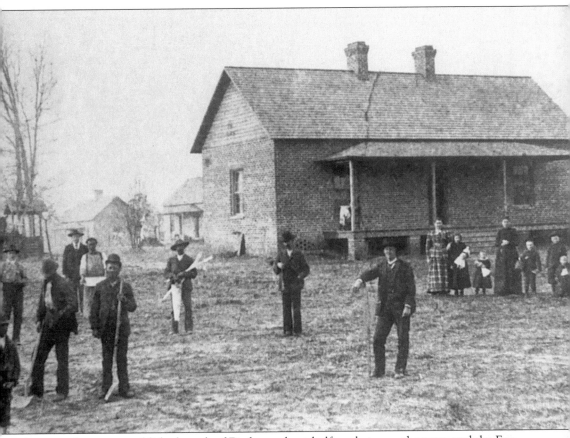

A county farm was established north of Durham, about halfway between the town and the Eno River, where indigents could be accommodated. The site of the old poorhouse is now home to Durham County Regional Hospital and Durham County Stadium, along with a prison for juvenile offenders and quarters for stray animals. (Courtesy Durham County Public Library.)

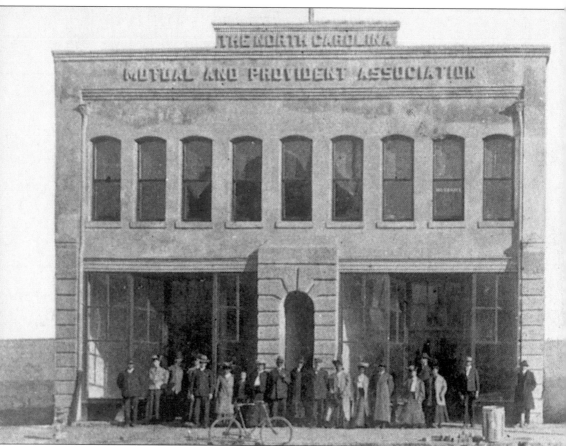

While white residents of Durham were making fortunes in tobacco and textiles, black citizens took part in the bullish economy of a booming town as well. The North Carolina Mutual and Provident Association, later to become the N.C. Mutual Life Insurance Co., helped bring Durham's downtown Parrish Street the designation "Black Wall Street of America." (Courtesy N.C. Division of Archives & History.)

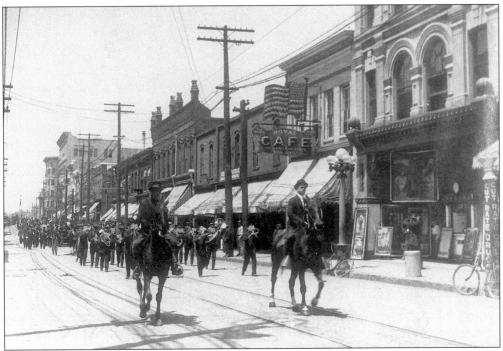

A horse-powered parade makes its way along Main Street, c. 1913. Note the electrified American flag over the Royal Cafe sign. (Courtesy Durham County Public Library.)

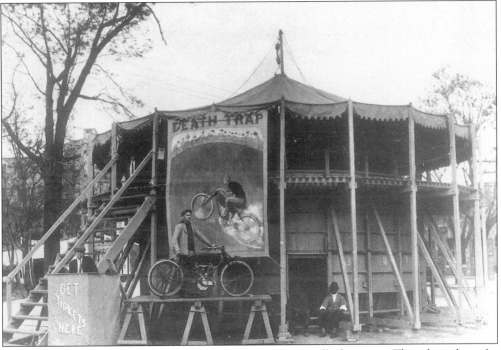

But with the turning of the 20th century, speed was all the rage. This showplace for daredevils on motorized bicycles was set up at a vacant lot downtown. (Courtesy Durham County Public Library.)

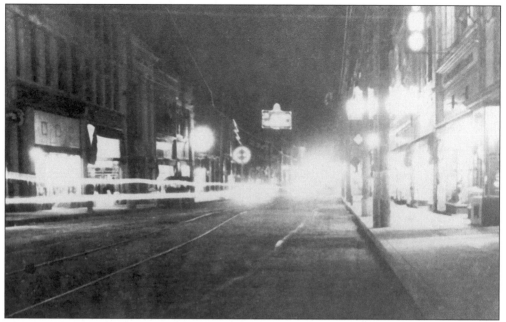

Electricity lit Durham up in 1913, when the Durham Traction Co.—the local electrical utility at the time—made a major advertising push to sell illuminated signs to the town's businesses. The result was this view of Main Street, around Christmastime, complete with the city's "Slogan Sign," high in the background. (Courtesy Durham County Public Library.)

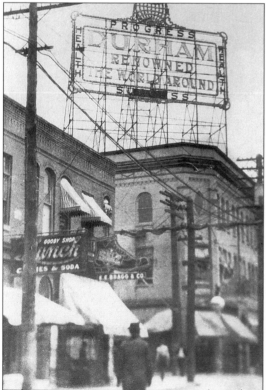

The Slogan Sign, erected as a promotion by the Durham Traction Co., proclaimed "Durham Renowned the World Around" from the top of the telephone exchange at Main and Church streets—in easy view of all passing trains. First lit to Christmas-shopping crowds in December 1913, the sign was soon damaged by a windstorm. In November 1919, a chamber of commerce committee decided that restoring the sign would cost more than it was worth. (Courtesy Durham County Public Library.)

Julian Carr, seen here with his grandchildren and a servant, was a partner in the W.T. Blackwell tobacco business and one of Durham's most important founding citizens. Carr was instrumental in creating textile and banking firms in Durham, the "Carr-olina" Hotel and the public library, among other institutions, and, even though he was a native of Chapel Hill, he provided the first endowment to Trinity College, now Duke University, in 1887—$10,000 worth of securities. A private in the Confederate cavalry during the War between the States, Carr earned the title "General" in later life, due to his activity in Confederate veterans' affairs. (Courtesy Durham County Public Library.)

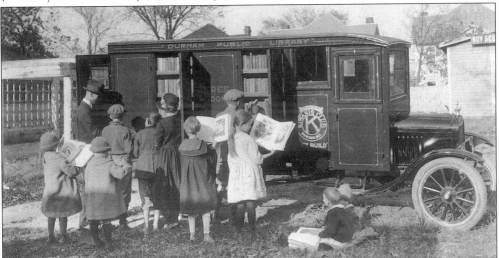

Thanks in large part to Julian Carr and his daughter Lalla Ruth, Durham had the first public library in North Carolina and one of the first bookmobiles. "Miss Kiwanis," so called in recognition of the Kiwanis Club's patronage, began service to the rural parts of Durham County in 1923. (Courtesy Durham County Public Library.)

The littlest reader. (Courtesy Durham County Public Library.)

Three
BULLY TIMES

Durham's association with the bull began soon after the Civil War, when tobaccoman John R. Green adopted the animal's likeness (from a jar of mustard made in Durham, England) as the emblem for his brand of smoking leaf. Using another sense of the word "bull," the connection may have been strengthened by the aggressive advertising that executives Julian S. Carr, of the Blackwell Co., and his major rival, James B. Duke (Washington's youngest son), employed to promote their products all around the world. The earliest use of the term "Bull City," as far as the author can determine, was by the Bull City Drug Co., a black-owned firm, around 1905.

An ornate angel marks the northern end of the Julian Carr plot at Maplewood Cemetery in Durham. A local legend has it that, after his wife, Nannie Parrish Carr, died, the "General" would ride the streetcar to her grave every afternoon and read the newspaper to her—at least, the society pages.

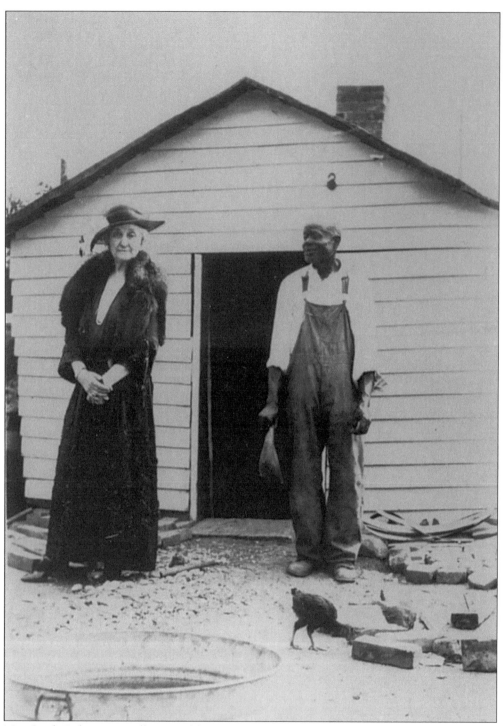

Mrs. Sarah Duke pays a call on neighbor Jerry Markham around 1924. Markham, who came to be known as the "Philosopher of Durham," was the guard at the Southern Railroad's Duke Street crossing, just down the hill from Four Acres, the Durham home of Ben and Sarah Duke. (Courtesy Duke University Manuscripts Collection.)

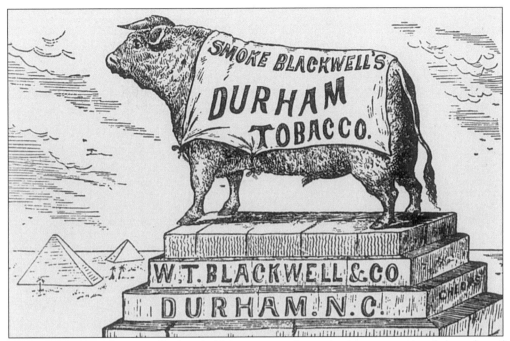

Both of the main players in Durham's 19th-century tobacco business appreciated the value of advertising. John Green originated the Bull Durham emblem, inspired by a brand of mustard manufactured in Durham, England, and his successors, W.T. Blackwell and Julian Carr, made it a trademark known around the world. (Courtesy Duke Homestead State Historic Site.)

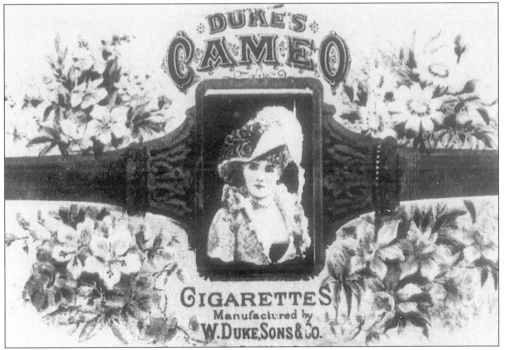

James B. Duke, no slouch himself at promotions, pioneered the use of attractive women as advertising for his family's brands of cigarettes. (Courtesy Durham County Public Library.)

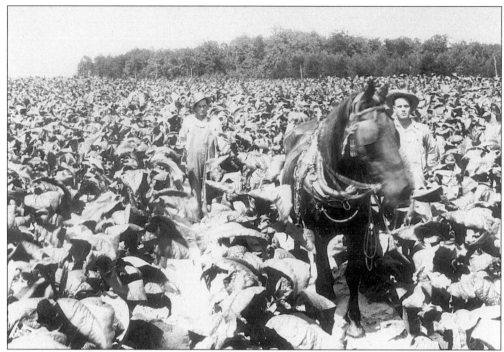

The town of Durham grew from 100 residents in 1860 to almost 20,000 in 1910, but the basis of Durham County's economy remained down on the farm, with folks such as this tobacco cultivator and its two-legged assistants. (Courtesy Durham County Public Library.)

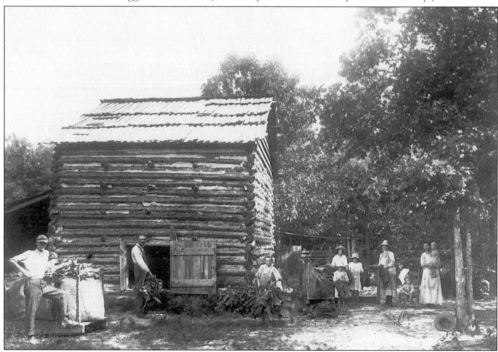

It is curing time on a county farm in this *c.* 1910 photograph. (Courtesy Duke Homestead State Historic Site.)

An auction day, about 1940, is shown here on Durham's "Tobacco Row." In the heyday of Durham's tobacco market, in the late 1940s, five auction houses operated more than half a million square feet of sales floor along Rigsbee Avenue. From late summer to early winter, tobacco sales brought the time everyone in town had money. (Courtesy Duke Homestead State Historic Site.)

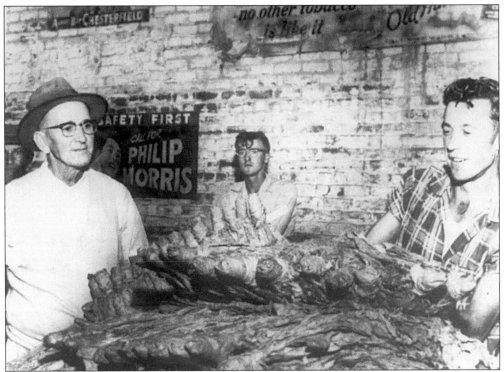

Farmers, warehousemen, and local merchants could rejoice over tobacco market season. This market-season photograph was taken in the 1940s. Market season meant everyone in the town had money. (Courtesy Duke Homestead State Historic Site.)

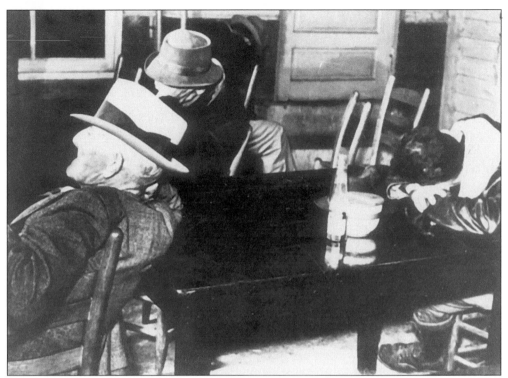

Tobacco farmers display a kind of patience that is almost surreal to the modern urbanite. Here, growers wait for the morning's sales after bringing the result of their year's labor into Durham markets. (Courtesy Duke Homestead State Historic Site.)

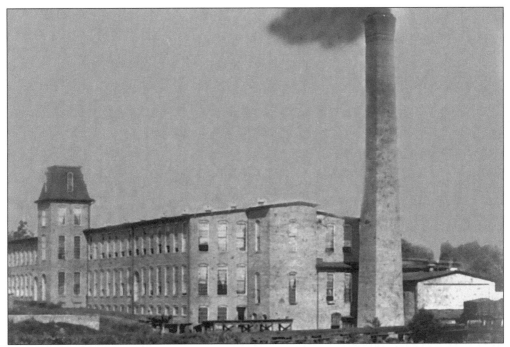

Pearl Mill, on West Trinity Avenue, was photographed about 1910. The mill was built in 1892 by Brodie Duke, the eldest of Washington's sons and the first to move from the family homestead into Durham, and was named for Brodie's younger daughter. Along with the mill, Brodie built workers' housing on Washington and Orient Streets, across the Belt Line railroad he had built the year before. (Courtesy Duke Homestead State Historic Site.)

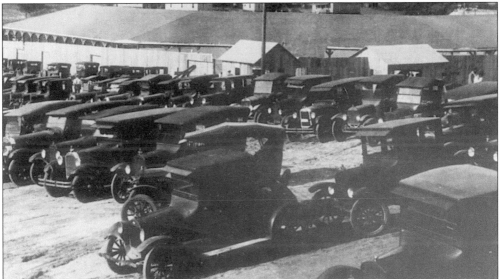

The parking lot is filled at the old East Durham ballpark on Driver Avenue, later the site of Holton Middle School, for a Durham Bulls game in 1927. Jerry Markham, a crossing guard at the Duke Street railroad intersection, was a regular and demonstrative fan at the Bulls' games, so much that he was pelted with tomatoes by rival fans at a game in Raleigh. (Courtesy Durham County Public Library.)

47

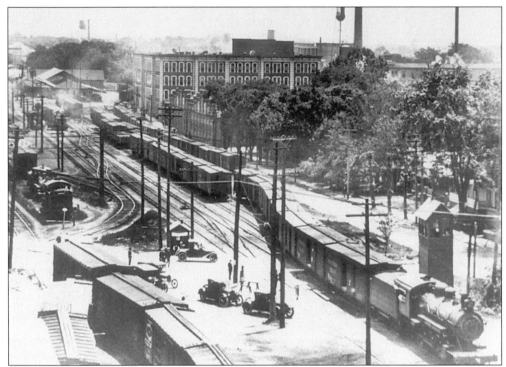

A switch engine shuttles freight cars around the Durham railroad yards around 1920. The American Tobacco cigarette factory huffs away in the background. Crossties from some of the old sidetracks may still be seen in the earth along Pettigrew Street. (Courtesy Durham County Public Library.)

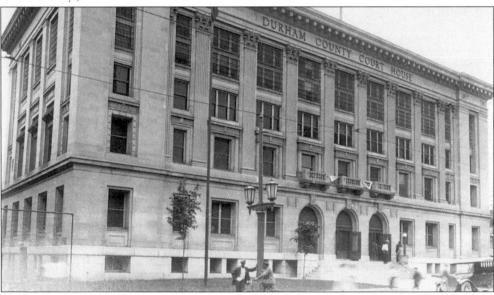

The Durham County Courthouse was completed in 1916. Designed in a Neoclassical Revival style by the firm of Milburn and Heister, the courthouse was remodeled in the 1980s for a county office building after a new judicial building was put up across Main Street. (Courtesy Durham County Public Library.)

In the 1940s, the W.C. Lyon Service Station occupied the site now home to the Durham Omni Hotel on Chapel Hill Street. Notice the Durham Auditorium, a.k.a. Carolina Theatre, in the background, as well as the rooftop parking at what is now an open plaza. (Courtesy Durham County Public Library.)

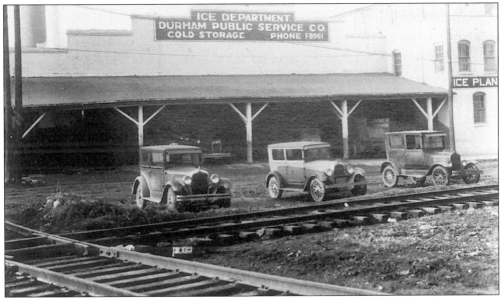

The Durham Public Service Co.'s ice plant, near the Liggett & Myers tobacco complex on Morgan Street, was photographed about 1920. The building was also headquarters of the Durham Traction Co., which ran the city's streetcars. (Courtesy Durham County Public Library.)

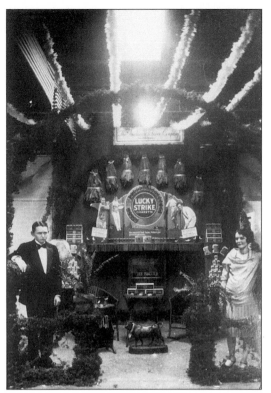

This Lucky Strike cigarette display may have been staged at a county fair. Notice the hearth motif, the athletic personalities showcased above the mantel with the sheaves of tobacco, and the stylish promoters posing like mannequins. (Courtesy Durham County Public Library.)

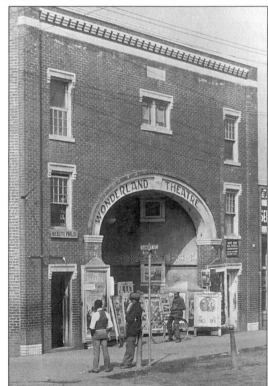

The Wonderland Theatre was part of the bustling African-American Hayti area along Pettigrew Street in downtown Durham. (Courtesy the *Herald-Sun*.)

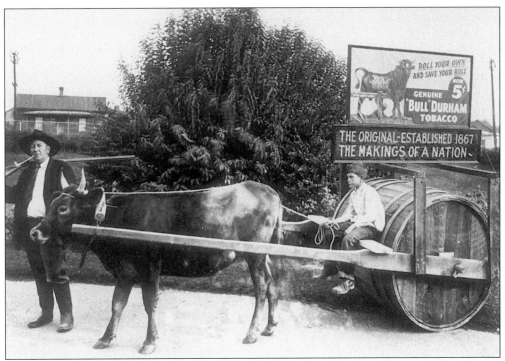

Durham may have been a bully city, but it did not forget its raisin' even in the Roaring Twenties. (Courtesy Durham County Public Library.)

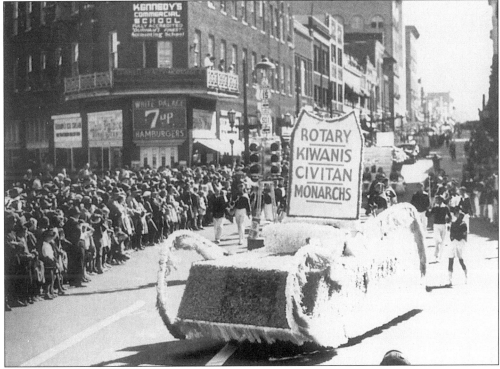

A parade passes through Five Points in 1936. (Courtesy Durham County Public Library.)

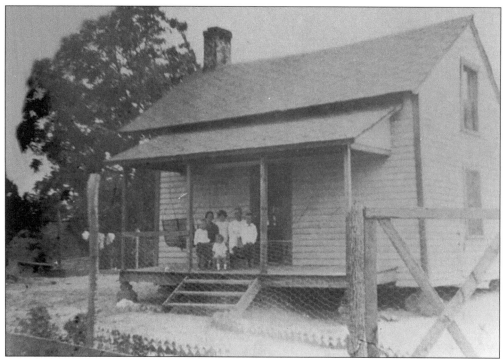

At home at the Booker Dairy in 1925 are Raymond Durrant Gibbs (seated) and, around him, from left to right, Leonard Staley Gibbs, Naomie H. Riggs Gibbs, Leona Gibbs, Staley Gibbs, and Epslin Gibbs. (Courtesy Durham County Public Library.)

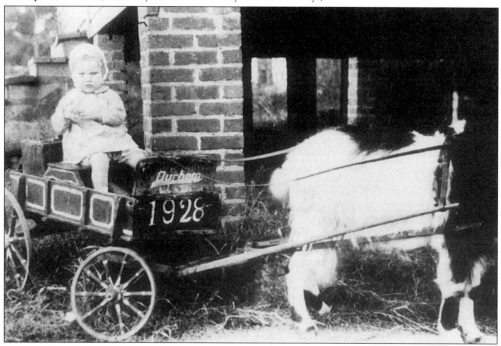

Margaret Bobbitt strikes a pose in her goat cart in the yard of her Spruce Street home, 1928. (Courtesy Durham County Public Library.)

Newlyweds Mr. and Mrs. William Cash strike a romantic pose on a tombstone, c. 1920. (Courtesy Durham County Public Library.)

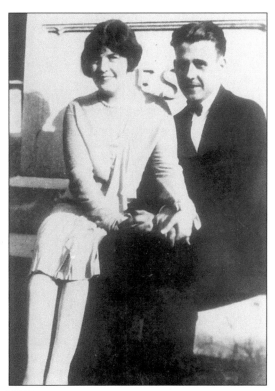

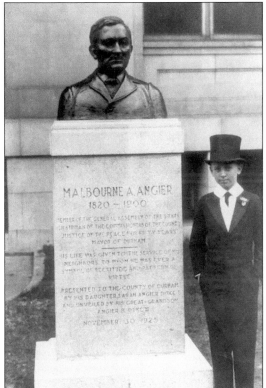

Young Angier Biddle Duke II tries to look serious for the unveiling of his namesake's bust at the Durham County Courthouse on November 30, 1925. Malbourne Angier was a former mayor of Durham and justice of the peace.

Here is a view looking west from Dillard Street in the 1920s. Hayti businesses in the thriving black district of Durham line Pettigrew Street to the left. (Courtesy Durham County Public Library.)

Main Street is all decked out for the Christmas buying season in the 1920s. The 1905 Trust Building, with its distinctive rounded corner, is in the right foreground. (Courtesy Durham County Public Library.)

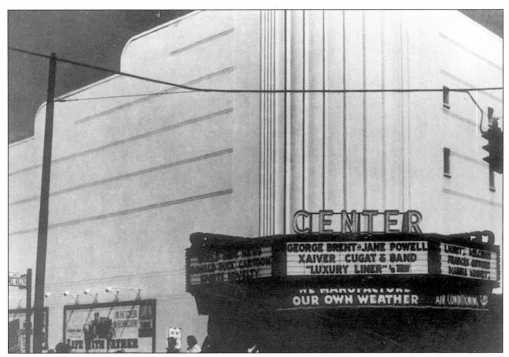

The Center Theater movie house in downtown Durham was known for its air conditioning—it was one of the first places in town to offer respite from the muggy piedmont summers—as well as its "mighty Wurlitzer organ." The theater moved to Lakewood Shopping Center in 1966 and closed in 1996. (Courtesy Durham County Public Library.)

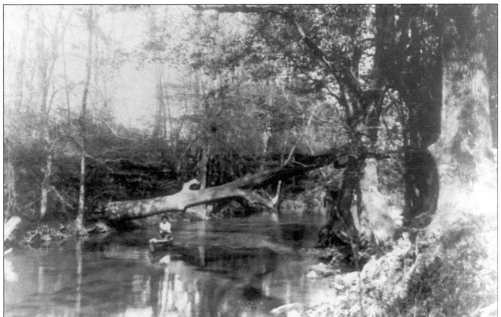

For years and years, the Eno River has afforded Durham residents a cool and calm retreat from urban pressures. A boater enjoys its placid waters in the 1920s. (Courtesy Durham County Public Library.)

Children take their pleasures where they may. This threesome decked themselves out for a make-believe wedding in the 1920s . . . (Courtesy Durham County Public Library.)

. . . while young Charles Nelson Ladd, around 1940, preferred gamier pursuits along Mason Road. (Courtesy Durham County Public Library.)

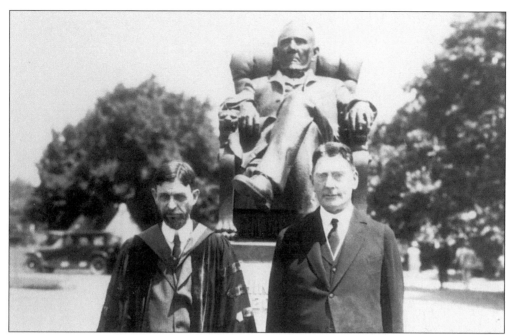

Duke University President William Preston Few, left, struck an academically serious pose with his college's benefactor, the bronze-faced Washington Duke, and an unidentified colleague around 1930. (Courtesy Durham County Public Library.)

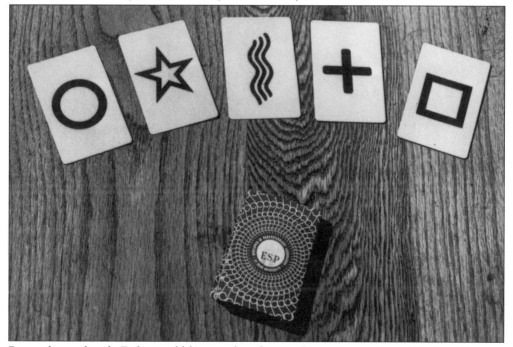

But within a decade Duke would become best known for two not-quite-academic endeavors. One was its football team, which went to the Rose Bowl in 1939; the other was the extrasensory perception experiments of Dr. J.B. Rhine. Duke psychologist Carl Zener designed a set of cards for Rhine to use in his mind-reading studies. (Courtesy Duke University Archives.)

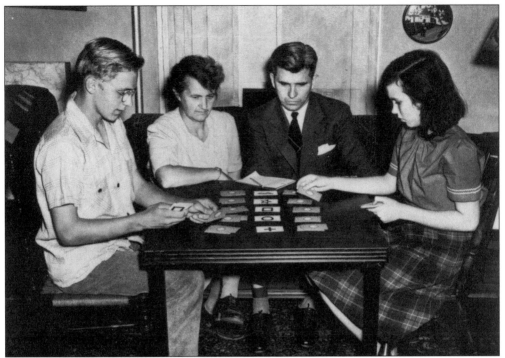

Louisa and J.B. Rhine, center, conduct an experiment in mind-reading with two young subjects in the 1930s. The Rhines' work in extrasensory perception brought international renown to the young Duke University, though it was not the sort of renown the university might have wanted or expected. (Courtesy Duke University Archives.)

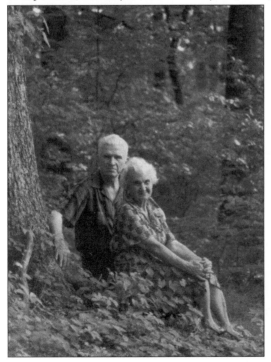

In the early 1960s, J.B. Rhine created the Foundation for Research into the Nature of Man, independent of Duke, to carry on his work in parapsychology. He and Louisa, his wife and lifelong colleague in psychic studies, made their home on a farm near Hillsborough.

Richard Nixon, later to become president of the United States, lived in this rustic cabin near the Duke campus during his third year of law school, 1936–1937. His younger brother Edward is pictured here at the cabin, which the elder Nixon called "Whippoorwill Manor." Electricity and indoor plumbing were amenities added after Richard Nixon left Duke. (Courtesy Duke University Archives.)

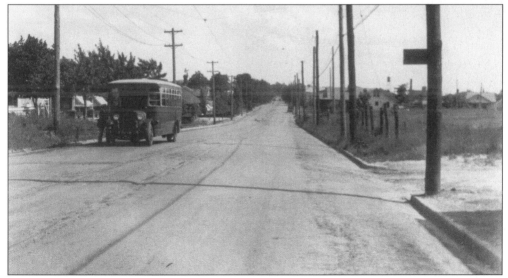

This view of Holloway Street, looking east, was captured about 1930. (Courtesy Duke University Manuscripts Department.)

Union Station was an Italian Renaissance Revival building erected in 1904 at the foot of Church Street through the legislatively encouraged cooperation of the Southern, Seaboard Air Line and Norfolk & Western railroads. It was torn down in 1967 to make way for the downtown Loop. (Courtesy Durham County Public Library.)

Four

AFTER THE WAR

Durham County interests did not welcome the U.S Army's decision to build a training camp in Durham, Granville, and Person Counties in 1941. Some of the best farmland in the area was lost; whole villages disappeared; 1,325 families—about 400 from Durham County—were relocated. Still, camp construction brought jobs, and Durham business took in the benefit of as many as 4,000 servicemen who came to town for relaxation (of various kinds) on any day. Military schools were also set up at Duke; one Saturday in 1943, every bottle of whiskey in the Durham liquor stores had been sold by noon. The war brought permanent changes in many ways—the mobility that pulled up people's old roots and provincial attitudes, for one, and, for another, added demands for a better deal for America's—and Durham's—people of color.

A Bastille Day party was held at the Dillard Street USO in 1944. The party was held in honor of a group of French air cadets training in Durham. World War II, and the construction of Camp Butner just north of Durham, brought as many as 4,000 servicemen a day into the city. (Courtesy Durham County Public Library.)

The war also brought a change in Durham's race relations. The city's first African-American police officers were sworn into duty in 1944, after the shooting of a black soldier by a white bus driver on Club Boulevard led to riot conditions in the town, and tensions between black GIs , white police, and the city's wartime population rose to something never anticipated. (Courtesy Durham County Public Library.)

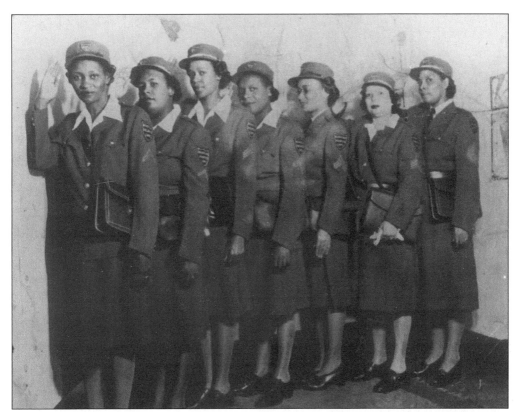

Pictured here are members of the National Beauticians' Volunteer Corps, a women's wartime service group. (Courtesy Durham County Public Library.)

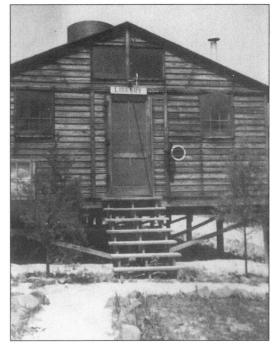

The Durham Public Library even opened a branch at Camp Butner. Like most of the camp's buildings, the library was built only well enough to last the duration. (Courtesy Durham County Public Library.)

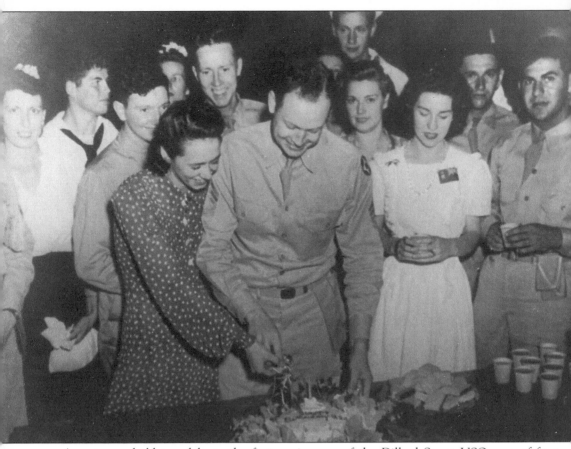

A party was held to celebrate the first anniversary of the Dillard Street USO, one of four servicemen's clubs in Durham during World War II. The anniversary fell on an auspicious date—June 6, 1944. (Courtesy Durham County Public Library.)

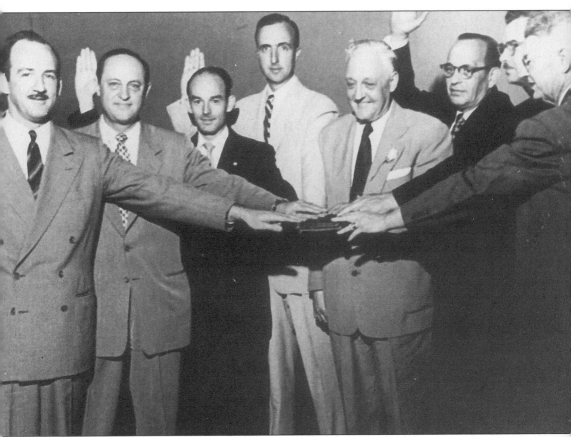

R.N. Harris, third from right, became the first African American elected to the Durham City Council, in 1953. Five years later, he was the first black person appointed to the city school board. (Courtesy Durham County Public Library.)

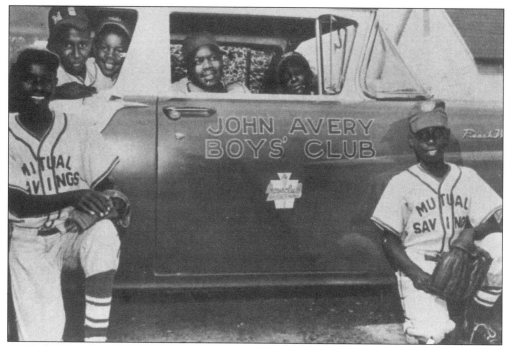

Baseball players gather in and around the John Avery Boys' Club van, c. 1950. Started in 1940 by the Negro Citizens Committee, the club offered sports, crafts, typing classes, manual-skills training, and a health clinic. (Courtesy Durham County Public Library.)

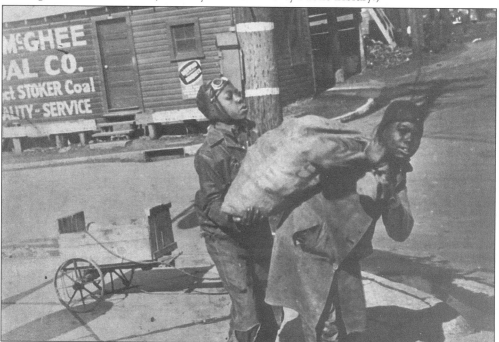

Joseph Johnson and Leroy Crawford delivered coal to make spending money as teenagers in the 1940s. Johnson wears an aviator cap and goggles, which were all the rage for boys at that time. (Courtesy Durham County Public Library.)

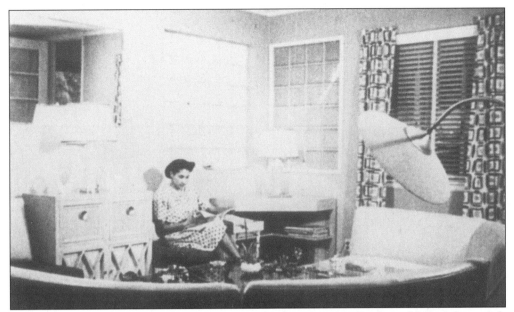

Here is a thoroughly modern living room of the late 1940s in Durham. Notice the stylish circular sofa. This photo is from the film *Negro Durham Marches On*, a promotion produced by the Durham Business and Professional Chain, a black counterpart to the Chamber of Commerce. (Courtesy Durham County Public Library.)

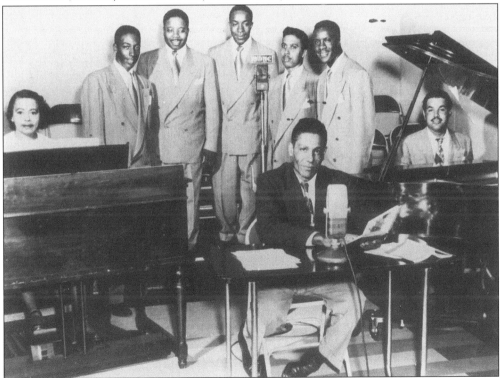

Radio personality Norfley Whitted introduces a five-man choir, augmented by piano and organ, on station WDNC in the 1940s. (Courtesy Durham County Public Library.)

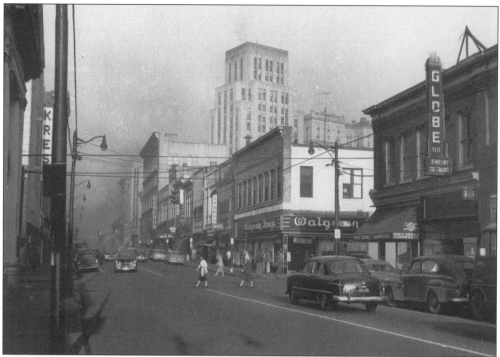

Downtown Durham is seen here about 1952. The Hill Building, the home of Durham Bank and Trust (now Central Carolina Bank) rises in the background. The Kress Building, at left, remains, but little else of businesses that were once landmarks. (Courtesy the *Herald-Sun*.)

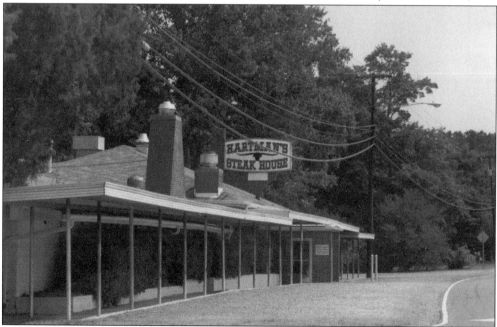

Hartman's Steak House on East Geer Street has been an institution since opening in the mid-1940s. Located several miles from the Duke University campus, Hartman's is recorded in college yearbooks as being a popular watering hole for undergraduates in the late '40s.

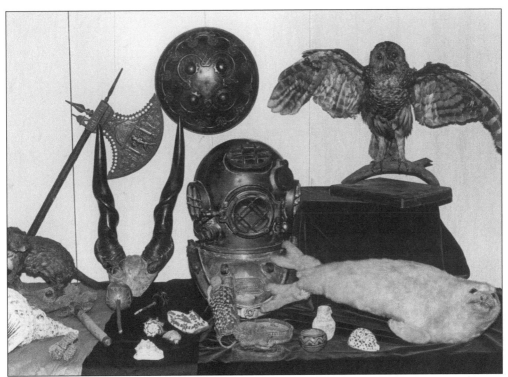

A diving helmet, pottery, and stuffed animals were among the early exhibits at the Durham Children's Museum, which opened in 1948 at Northgate Park. (Courtesy the *Herald-Sun*.)

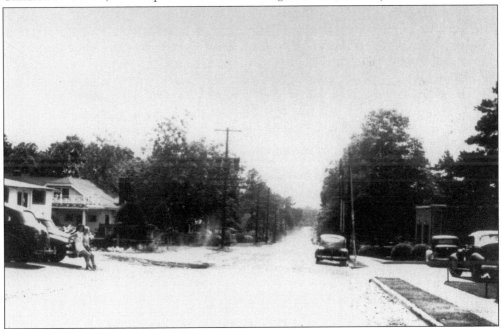

In time, the museum would relocate to Murray Avenue in northern Durham. In the 1950s, Murray, which runs west from the Bragtown neighborhood, was still a dirt road. (Courtesy Durham County Public Library.)

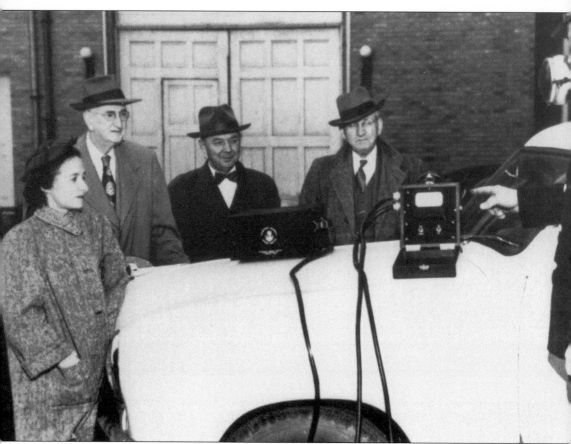

Members of the City Council get a look at the "whammy," Durham's first traffic-radar unit, in 1952. (Courtesy Durham County Public Library.)

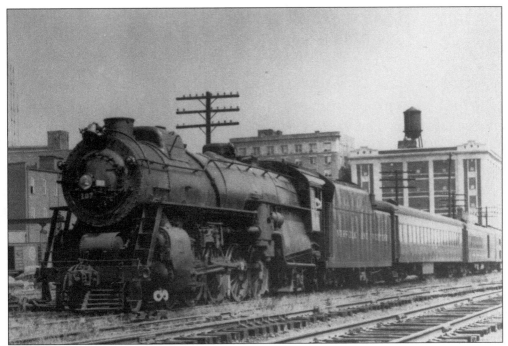

Durham was founded to accommodate the railroad. Old-timers fondly recall the steam behemoths, like this Norfolk & Western 4-8-2, that once chugged through the heart of town. (Courtesy Durham County Public Library.)

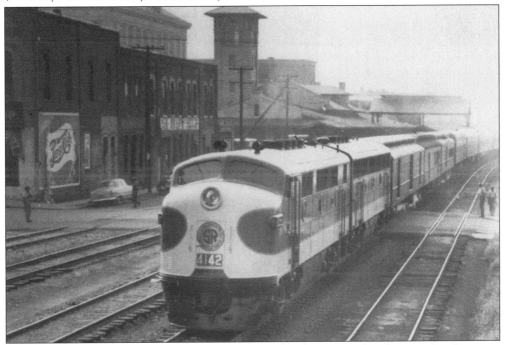

But the early 1950s brought change on the lines, as diesel power replaced steam. Southern was the first American railroad to completely convert to the new form of motive power. (Courtesy Durham County Public Library.)

Air travel began usurping railroad business in the 1950s. Raleigh-Durham Airport, constructed between the two cities during World War II, took the place of several earlier municipal air facilities. Today, it serves international flights as well as domestic, but its first terminal had a rather provincial quality. (Courtesy Durham County Public Library.)

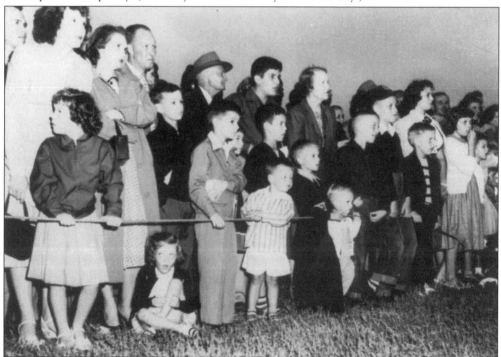

Fascinated with flight, a crowd presses for a good view at an air show at the Raleigh-Durham Airport, c. 1950. (Courtesy N.C. Division of Archives and History.)

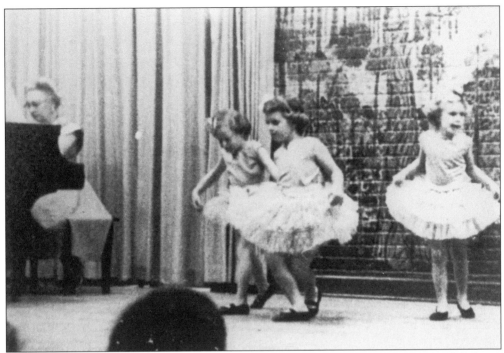

Young ballerinas put their best feet forward—at least, as best they can—at the Twaddell dance and music school's recital. (Courtesy Durham County Public Library.)

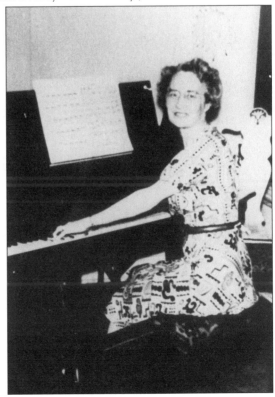

School director Vera Carr Twaddell is at her post at the piano. (Courtesy Durham County Public Library.)

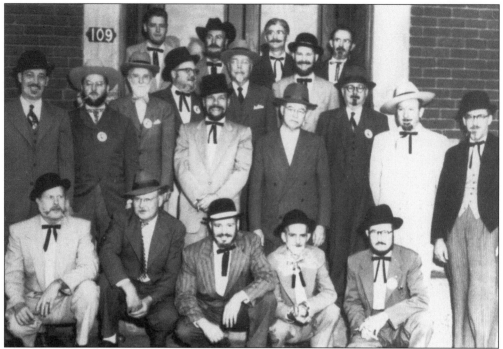

These gentlemen show off new chin whiskers and period clothes, getting into the spirit of Durham's city centennial party in 1953. (Courtesy Durham County Public Library.)

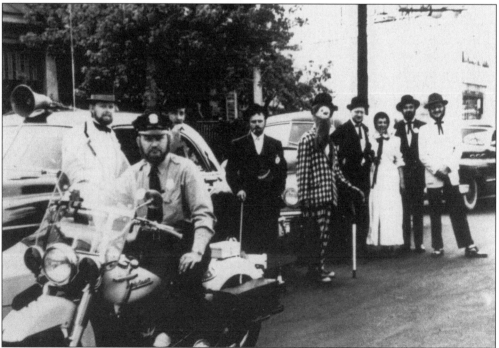

Beards were de rigeur for gentlemen during the city centennial, even for Durham's Finest. The year 1953 was actually the 100th anniversary of the establishment of a post office at Durham's Station; the city was not incorporated until 1869. (Courtesy Durham County Public Library.)

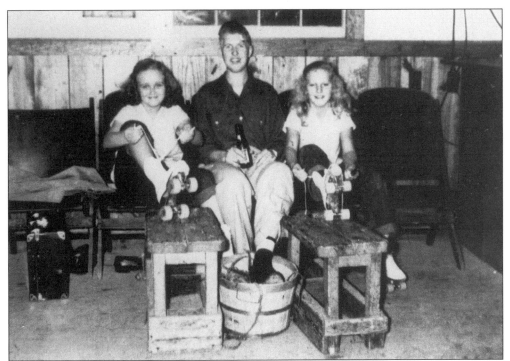

Skaters have fun at Cash's Roller Rink. The girls are Judy Gaddy and Todey Pickett; their male companion is unidentified. (Courtesy Durham County Public Library.)

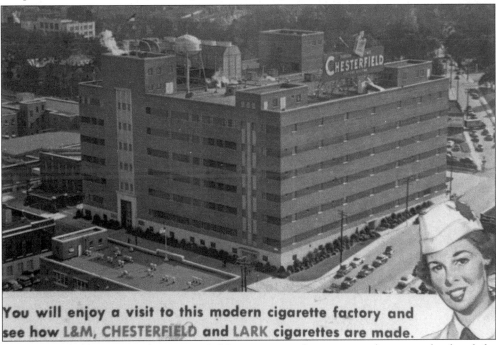

You will enjoy a visit to this modern cigarette factory and see how L&M, CHESTERFIELD and LARK cigarettes are made.

The Chesterfield sign atop the Liggett & Myers cigarette factory was a downtown landmark for decades. In the 1950s, when this postcard was printed, cigarette factories gave regular public tours—and free samples of their products. (Courtesy Milo Pyne.)

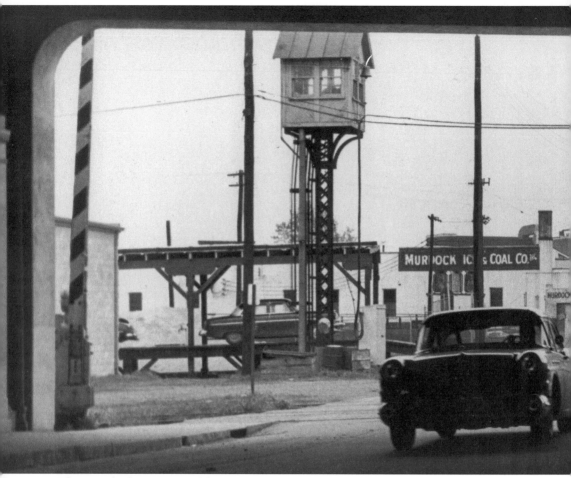

This view looks east toward downtown from Morgan Street, under the Liggett & Myers factory bridge. The ice plant at left, behind the oncoming automobile, operated until the mid-1970s.

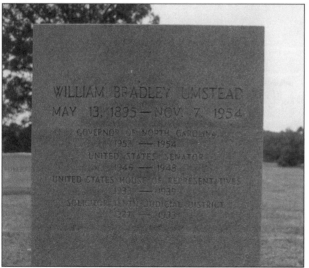

The only North Carolina governor ever elected from Durham County, William Bradley Umstead died in office in 1954. He was buried in a family section at Mount Tabor United Methodist Church, near Bahama.

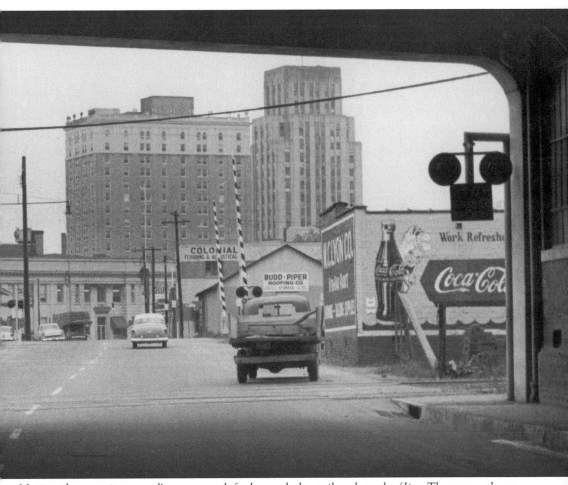

Notice the crossing guard's tower at left, beyond the railroad track. (Jim Thornton photo courtesy the *Herald-Sun*.)

Wiley Bowling, an aspiring photographer, made this self-portrait in his backyard, on Gattis Street. (Courtesy Durham County Public Library.)

Carlin Graham, a scoutmaster and professional photographer, was Bowling's photographic mentor. (Courtesy Durham County Public Library.)

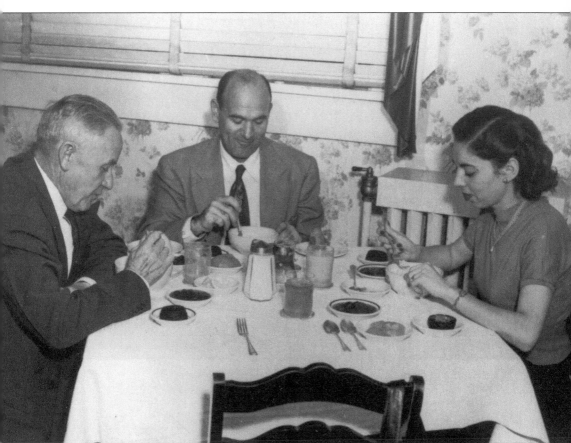

A new industry came to Durham in the 1930s and 1940s with Dr. Walter Kempner's Rice Diet. Originally devised for treating kidney disorders, diabetes, and hypertension, the diet's weight-loss side effect brought streams of celebrities to Kempner's Duke clinic, putting up with the doctor's autocratic personality and strict regimen to live on rice, fruit, and little else for weeks or months. Here, Kempner, center, shares a "meal" with two unidentified patients. (Courtesy Duke University Archives.)

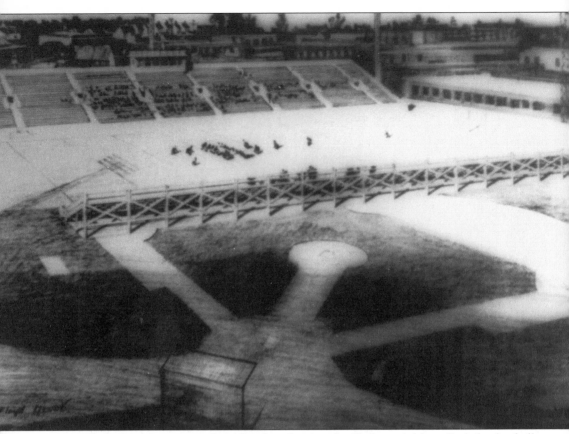

A 1950s designer came up with a plan for adapting the Durham Athletic Park for football as well as baseball; however, this change never came about. In 1960, the county built a stadium for high-school football teams on part of the old County Home property off North Duke Street. (Courtesy Durham County Public Library.)

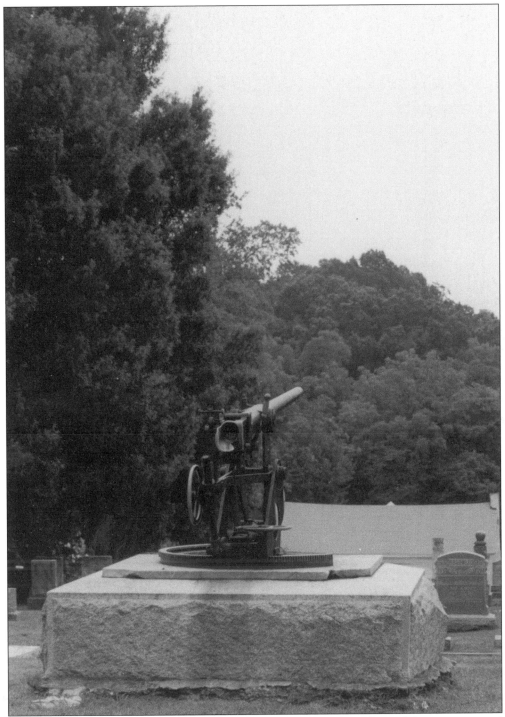

A Spanish-American War naval gun aims east from a section of Maplewood Cemetery, toward the backyard of a house once lived in by African-American businessman Robert Fitzgerald. Fitzgerald's granddaughter Pauli Murray wrote a memoir about growing up in Durham in the 1910s, titled *Proud Shoes*. She remembered the gun.

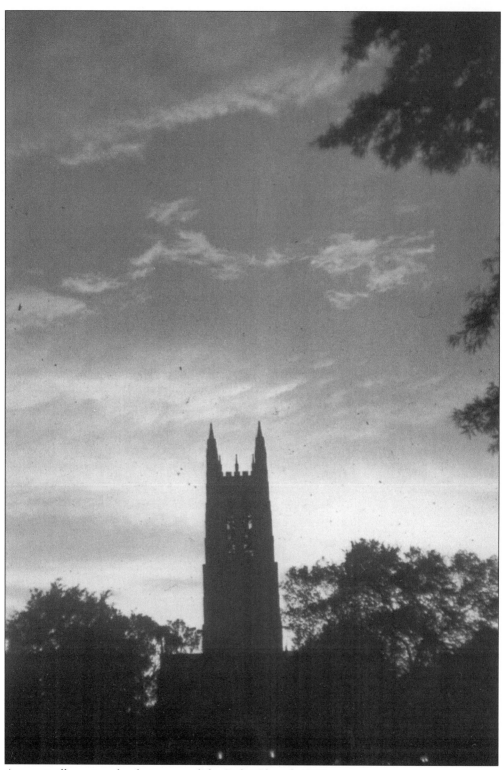

A sunset silhouettes clouds, trees, and the Duke Chapel, 1968.

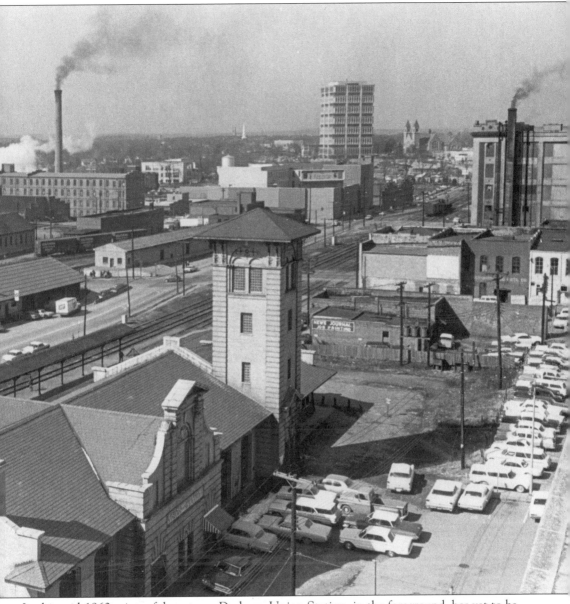

In this mid-1960s view of downtown Durham, Union Station, in the foreground, has yet to be razed to make way for the Downtown Loop, and chugging smokestacks bespeak a town still flush with industrial vigor. (Courtesy the *Herald-Sun*.)

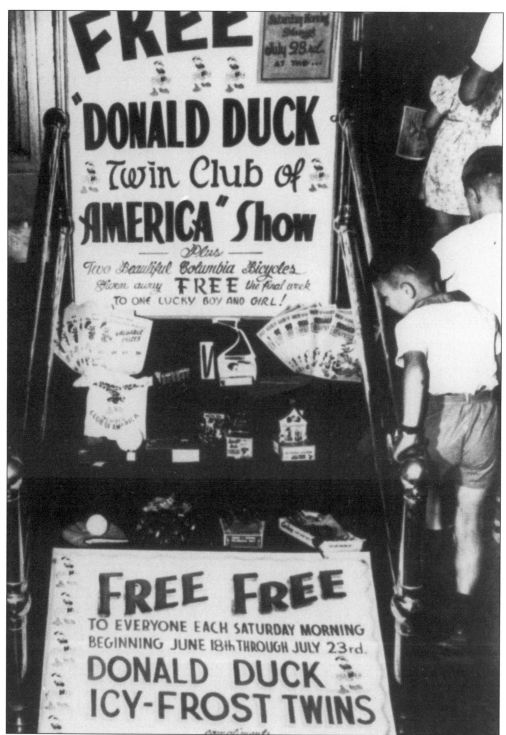

Youngsters pass through the lobby for a Saturday-morning movie at the Carolina Theatre. The Donald Duck Twin Club of America was holding a contest for a pair of bicycles—one boy's, one girl's. (Courtesy Durham County Public Library.)

Five

A FREEWAY
RAN THROUGH IT

Change—demands for it and questions of what to do about it—reached crisis points in the 1960s and early 1970s. In Durham, changes were social, economic, visual—and usually in combinations of all three and more. A Durham black man, Thomas Hocutt, had brought the first challenge to segregation in higher education in 1933 (unsuccessfully), and a sit-in demonstration had taken place at the Royal Ice Cream Co. in 1957. But it was a 1960 series of lunch-counter demonstrations, with a stirring address by the Rev. Martin Luther King at White Rock Baptist Church, that brought the Movement into the Bull City with force. Meantime, urban renewal had wiped out much of the bustling Hayti section, and construction of an expressway obliterated familiar geography and cut a raw swath through the city's heart.

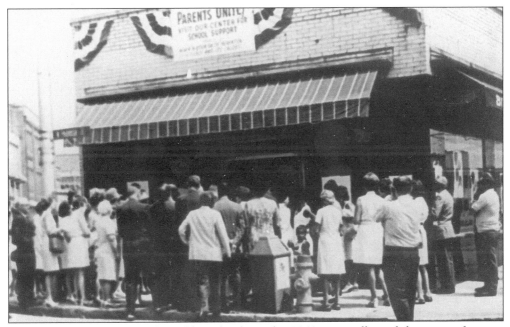

Parents united to support the public schools in the 1960s, one effect of the wave of citizen activism that characterized the decade and would change Durham forever. (Courtesy Durham County Public Library.)

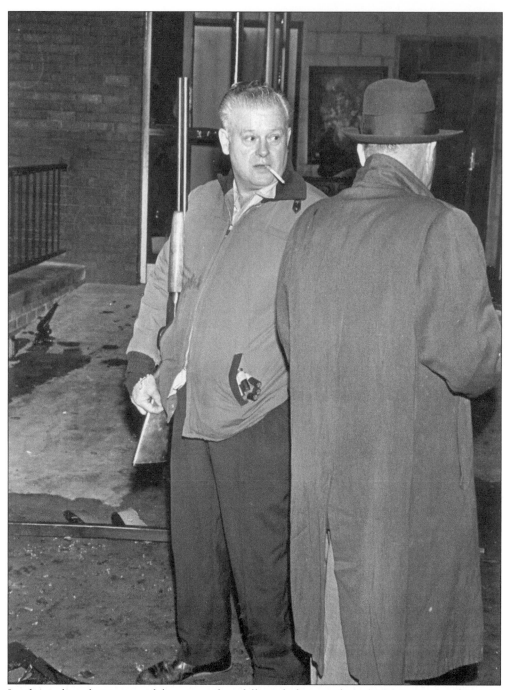

In the wake of rioting and burnings that followed the murder of Martin Luther King in Memphis, a Ninth Street businessman took public safety into his own hands on April 6, 1968. (Harold Moore photo courtesy the *Herald-Sun*.)

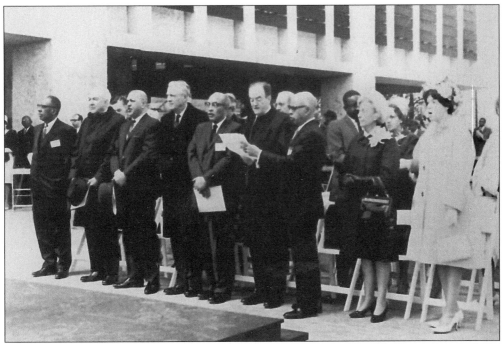

Dignitaries, including Vice President Hubert H. Humphrey, sixth from left, stand for the opening ceremonies of the N.C. Mutual building, the headquarters of the largest black-owned financial institution in the United States, on April 2, 1966. (Courtesy Durham County Public Library.)

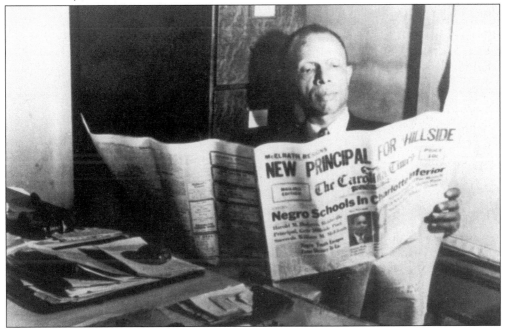

Louis Austin bought controlling interest in the *Standard Advertiser* newspaper in 1927. He changed the name to *Carolina Times*, and made the Durham paper a crusading voice of the proto-civil rights movement. (Courtesy Durham County Public Library.)

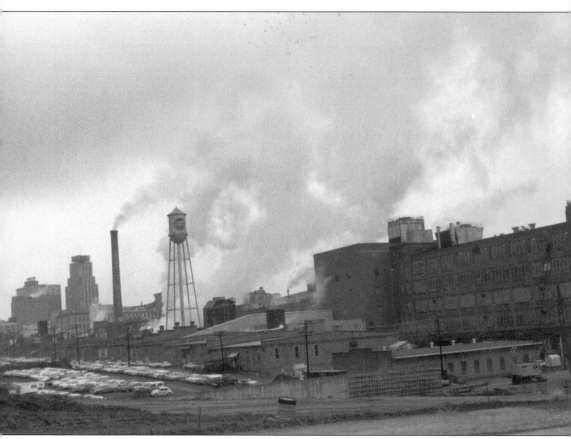

Seen here are the American Tobacco factory, with its landmark Lucky Strike water tower, and downtown Durham's Central Carolina Bank building and Jack Tar Hotel in the background. In the foreground, land has been cleared for the Durham Freeway. This photo was taken in December 1967.

This view was captured looking north from the approximate present location of the Henderson Towers senior citizens' home on Morehead Avenue. Taken in December 1967, the photo shows construction under way at the Duke Street-Durham Freeway interchange.

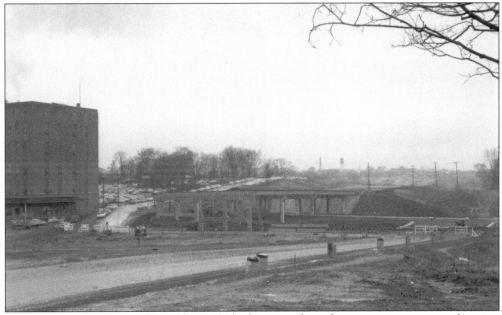

This photograph, taken in December 1967 looking east from the approximate present location of the Henderson Towers senior citizens' apartments on Morehead Avenue, shows construction under way at the Blackwell Street-Freeway intersection. A portion of the American Tobacco factory appears at left; the parking lot site beyond the bridge construction is now occupied by the Durham Bulls Athletic Park.

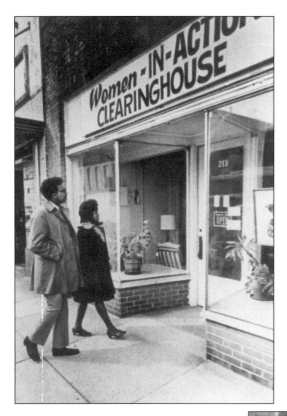

The 1960s brought activism to visible attention in Durham. Women in Action for Prevention of Violence was started in 1968 by Elna Spaulding to encourage interracial cooperation. The organization made its headquarters on Parrish Street, in the heart of the business district once called America's "Black Wall Street." (Courtesy Durham County Public Library.)

Public demonstrations for desegregation also became a part of the Durham landscape. One of the first sit-ins took place at the downtown Woolworth's lunch counter in February 1960. The counter has since been relocated to the snack bar at the N.C. School of Science and Mathematics on Broad Street. (Courtesy Durham County Public Library.)

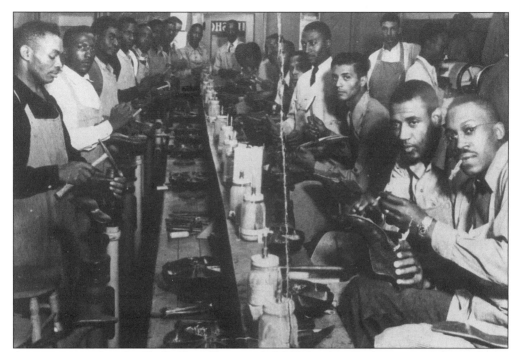

Apprentices work at the Shelly Shoe Shop, *c.* 1940. While white Durham grew with its tobacco and textile industries, a separate African-American city developed south of the railroad in the section called "Hayti." Hayti was fertile ground for dozens of home-grown businesses and a vibrant black culture. (Courtesy Durham County Public Library.)

White Rock Baptist Church was one of many Hayti institutions that relocated farther south in the 1960s and 1970s as urban renewal and desegregation changed the population patterns of Durham. Martin Luther King and Ralph Abernathy came to speak at White Rock in February 1960, supporting the N.C. Central University students' sit-in at the Woolworth's lunch counter downtown. (Courtesy Durham County Public Library.)

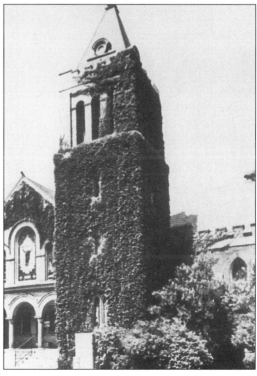

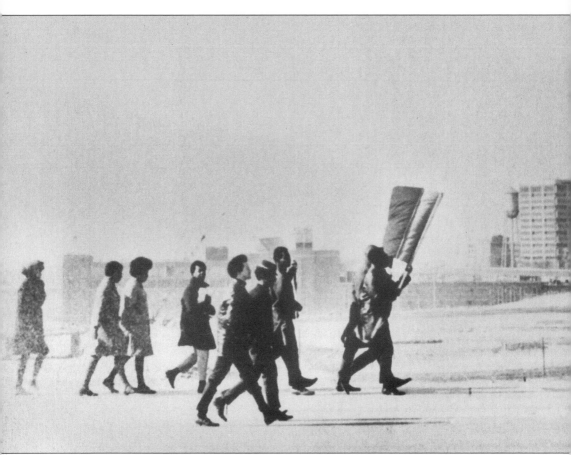

Protest marchers walk across the Fayetteville Street bridge over the Durham Freeway in the late 1960s. The N.C. Mutual building appears in the background, along with the American Tobacco factory. The empty space in the middle ground was formerly occupied by Hayti, the bustling black section of Durham sacrificed to urban renewal in the early 1960s. (Courtesy Durham County Public Library.)

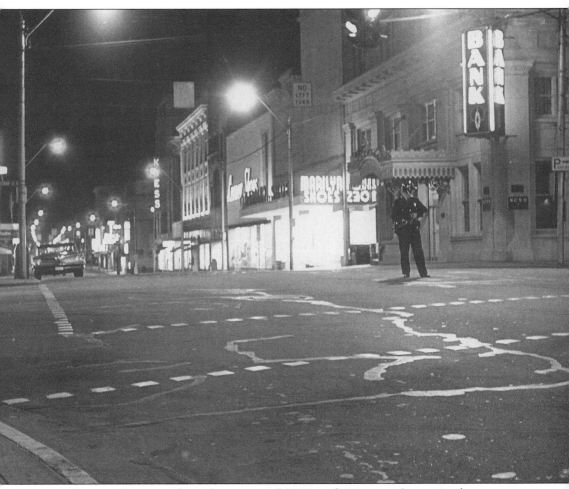

A lone policeman keeps watch at the corner of Main and Corcoran Streets in downtown Durham on April 7, 1968. Rioting in reaction to the murder of Martin Luther King in Memphis provoked a city-wide curfew. (Harold Moore photo courtesy the *Herald-Sun*.)

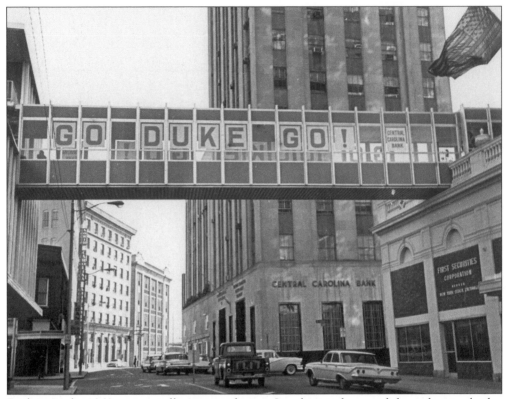

Durham in the 1960s was not all serious and tense. Local spirit decorated the pedestrian bridge over Corcoran Street between the parking deck and Jack Tar Hotel for Vic Bubas's Final Four basketball team. (Courtesy the *Herald-Sun*.)

Flower Power and its associated irreverence arrived at Duke University in various forms, such as this "Be-In" at the Sarah P. Duke Gardens in the fall of 1966.

All movements, however, run their courses, and by the spring of 1970 some at Duke and in Durham were getting a fill of the 1960s.

An early snowfall swathed the Duke Gardens in December 1973, but, as the footprints demonstrate, the work of academia does go on.

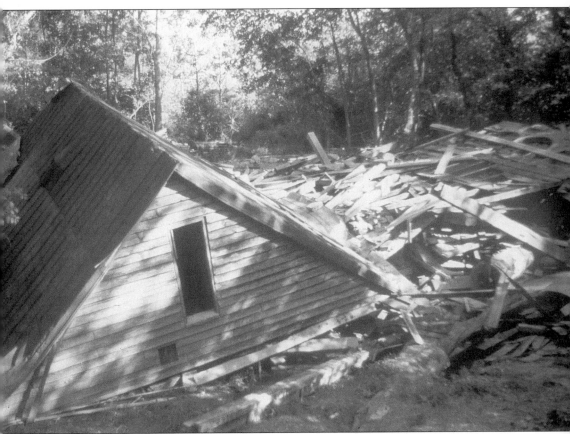

Weather in the early 1970s had its way with another Durham landmark. The old Christian's Mill, on the Eno River at Roxboro Road, had been put out of business by a flood in 1942 but remained standing until a gullywasher in February 1972 laid it low for good. (Courtesy West Point on the Eno Park.)

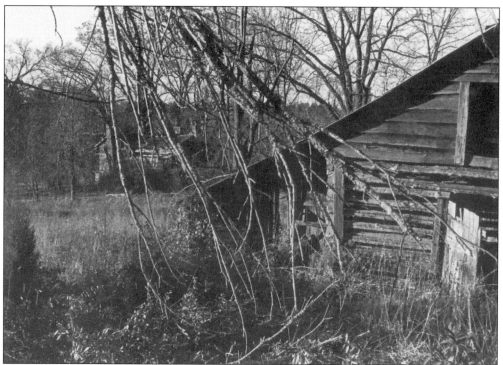

Durham's heritage seemed to be fading back into the earth in the early 1970s, this decaying farmstead off Johnson's Mill Road being a case in point.

Even the public library found itself tried hard by changing times. The overcrowded and outdated building on Main Street was stretched and stressed to accommodate a burgeoning community of clients, as well as quirks of nature. (Courtesy Durham County Public Library.)

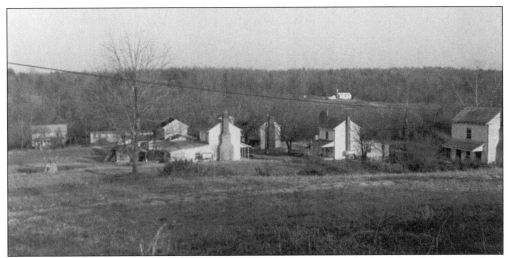

The forces of progress arrived at Orange Factory, a mill village on the Little River, in the early 1980s. Established in 1852, the factory secured its future with a government contract to manufacture Confederate uniforms. It continued in business until 1938, and the community that grew up around it survived until it was flooded by the Little River Reservoir in 1987. (Courtesy the *Herald-Sun*.)

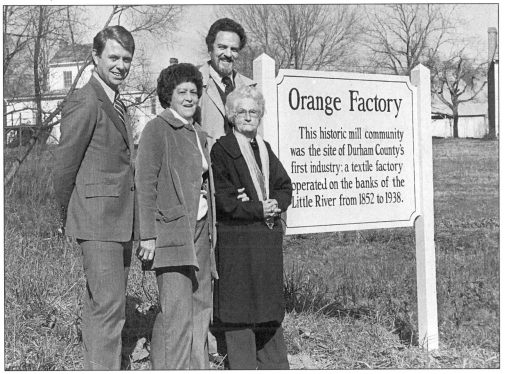

Too little, too late. An Orange Factory Preservation Society was organized in the late 1970s. From left to right, John Flowers, Ruth Suggs, Norris Post, and Callie Ellis pose by a historic sign placed at the village in November 1979. Preservation, however, lost out to the water demands of a growing city, and the site of Orange Factory now lies in the bed of an artificial lake. (Courtesy the *Herald-Sun*.)

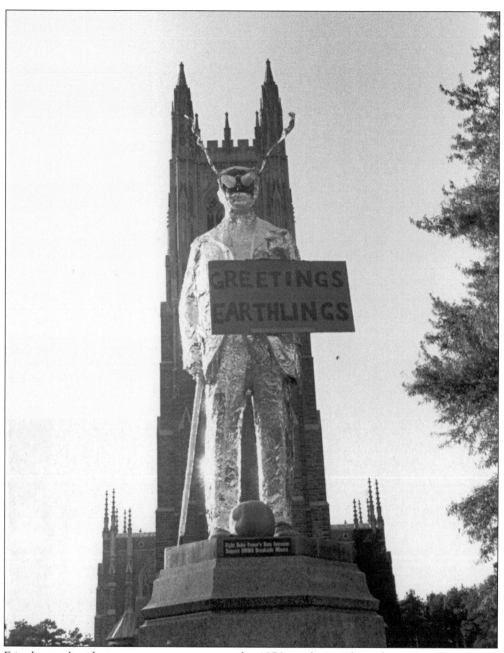

Frivolity replaced earnestness on campus as the 1970s took over from the 1960s. A swarm of flying-saucer reports in October 1974 inspired this Halloween makeover for James B. Duke.

Six

BICENTENNIAL, BORN AGAIN

The U.S. Bicentennial of 1976, coming hard upon the passions roused and divisions cut by the Civil Rights movement, the Vietnam War, sexual revolution, flower power, and Watergate, stirred a renewed interest in local community and connection with the local past. Hometown festivals and historical dramas proliferated across the country. Durham discovered a new form of community and civic identity emerging with its downtown arts festival, Centerfest; its Fourth of July folklife celebrations at an Eno River Park just rescued from development and a dam; and the rebirth of the Durham Bulls baseball team in 1980. Such new institutions, and some others, connected newcomers and old-timers, academics and millhands—disparate segments of the population that had found little common bond or interest in the years before.

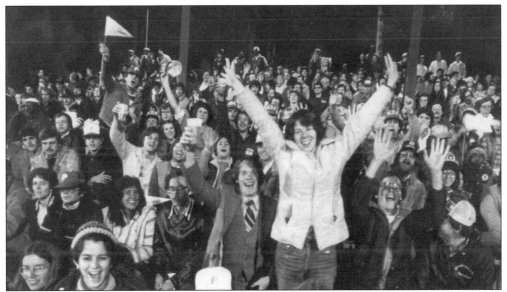

Fans cheer as baseball returns to the Durham Athletic Park on Morris Street. Reincarnated in 1980 as a farm team of the Atlanta Braves, the Durham Bulls became a showcase franchise for minor-league baseball and a signature institution in a reinvigorated city. The team's success even hit Hollywood, as Durham native Thom Mount produced the 1988 feature movie *Bull Durham*. (Jim Thornton photo courtesy the *Herald-Sun*.)

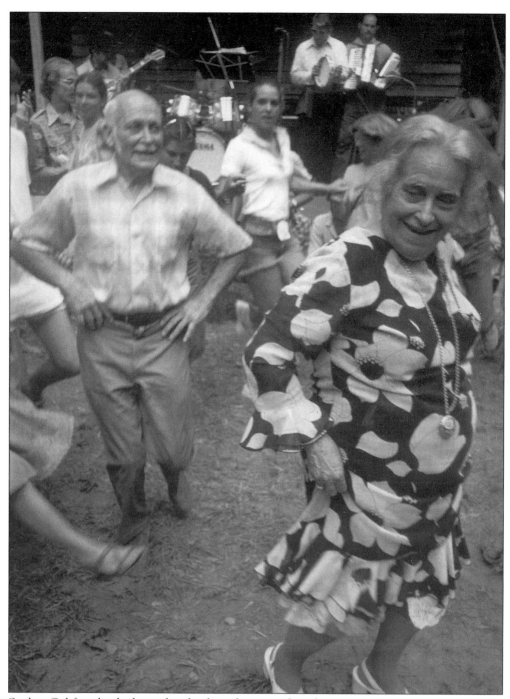

Sophie Galifianakis kicks up her heels and tugs up her skirts to the lively music of Kombo Hellas at the North Carolina Folklife Festival staged at West Point Park in July 1978. The festival, fourth in a series originated by Duke undergraduate George Holt, inspired the Association for the Preservation of the Eno River Valley to establish its Festival for the Eno at West Point. Held on the Fourth of July weekend every year since 1980, Festival for the Eno has become as much a part of Durham heritage as the aroma of tobacco.

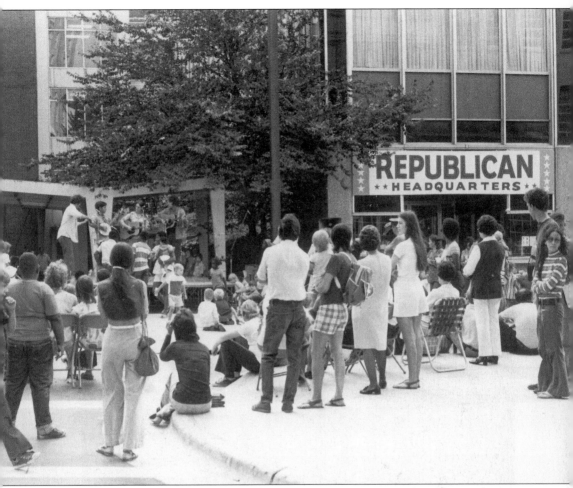

Durham began taking account of its own heritage in the 1970s, particularly with regard to its failing downtown business district. Allied Arts of Durham, a suburban organization setting out to stake a place for itself at the community's core, staged its first "Street Arts Celebration" in September 1974. At the time, it seemed to be a juxtaposition of incongruous elements.

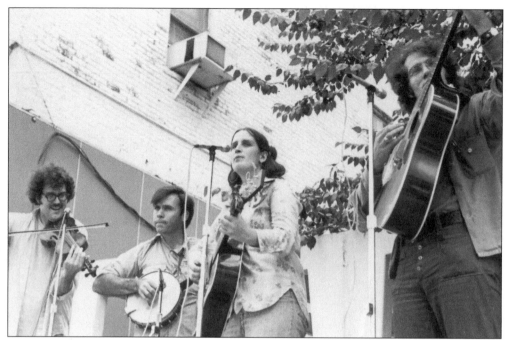

Fiddlin' Dave McKnight, D.L. Bishop, Diane Leonard, and Johnny Carroll Huff made up the Joel Haswell Revue. Their bluegrass act closed the card of Allied Arts' first Street Arts Celebration.

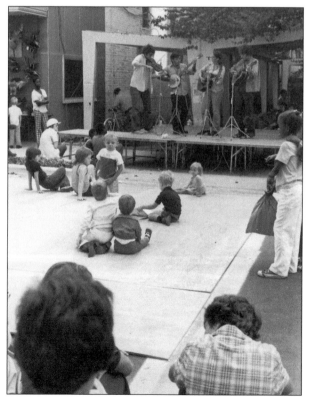

Kids and plywood—but what to make of such an opportunity? In 1974, chalk drawing on sidewalks was not yet a part of festival culture. The Street Arts Celebration, now called "Centerfest," has become a Durham institution. The 1970s saw Allied Arts of Durham change its name to "Durham Arts Council" and move from Proctor Street in the Morehead Hill neighborhood to the old city hall downtown.

Many onlookers that afternoon seemed uncertain what to make of it all in downtown Durham, Main and Market Streets, September 1974. The first time arts came downtown.

Begun in a small building at Northgate Park, the Durham Children's Museum grew through the 1950s and 1960s to be the N.C. Museum of Life & Science on Murray Avenue. During the 1970s, the museum came to acquire the best collection of aerospace artifacts between the Smithsonian Institution and Cape Canaveral. (Courtesy the *Herald-Sun*.)

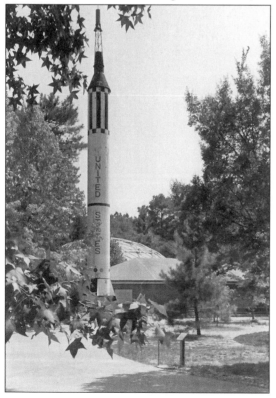

The Redstone rocket and Mercury capsule at the Museum of Life & Science were duplicates of the actual hardware that put the United States' first astronauts into space in 1961. (Harold Moore photo courtesy the *Herald-Sun*.)

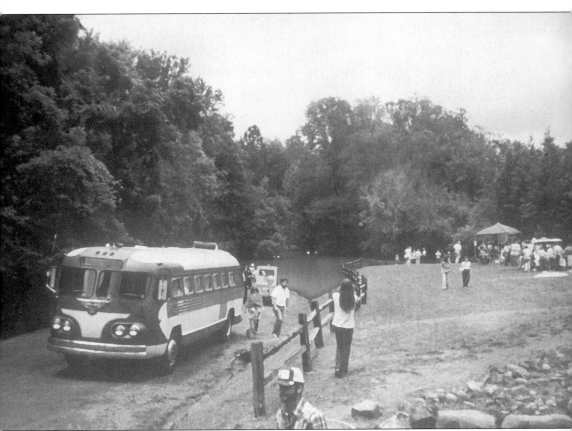

So what's a little weather? In spite of heavy rain, the Eno River Association held its second Festival for the Eno on the Fourth of July weekend, 1981, at West Point Park. (Courtesy West Point on the Eno Park.)

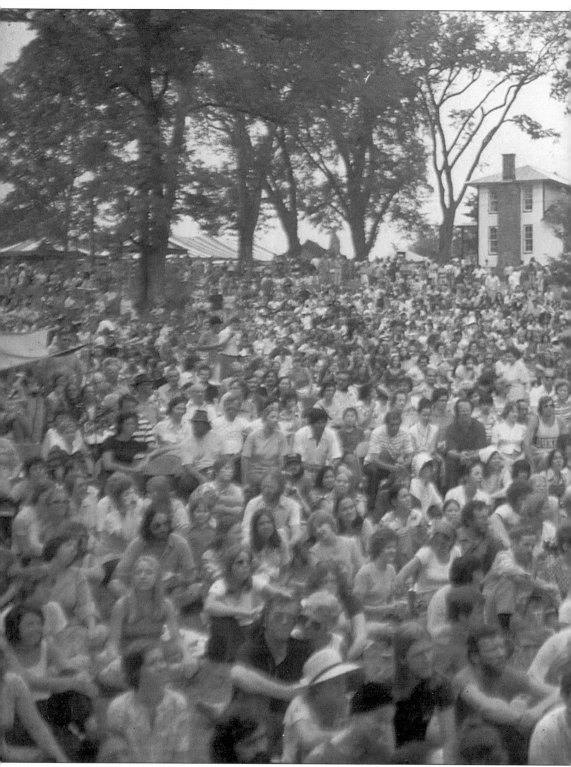

If you build it, they will come. A crowd gathers at the Meadow Stage for the N.C. Folklife

Festival in 1978. (Duncan Heron photo courtesy West Point on the Eno Park.)

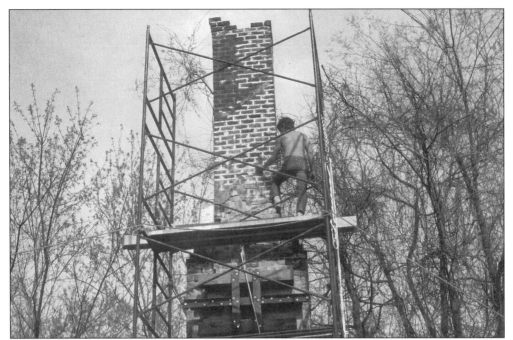

With the bicentennial came a spirit of rebuilding Durham's vanishing past, including this chimney at the West Point gristmill. A mill from Virginia was moved into the park and restored to working condition in time for the 1976 Bicentennial Festival of N.C. Folklife. (Courtesy West Point on the Eno Park.)

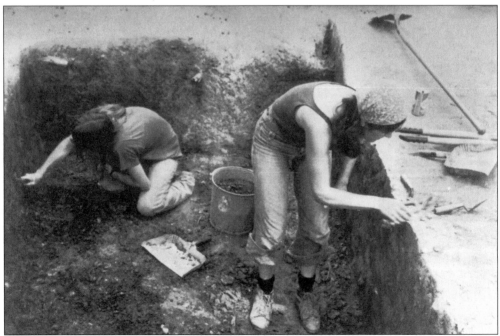

Archaeologists Helen Haskell and Terry Erlandson excavate a 19th-century cellar at Duke Homestead. The 4-foot-deep cellar had appeared as simply a discoloration on the soil surface. (Courtesy Duke Homestead State Historic Site.)

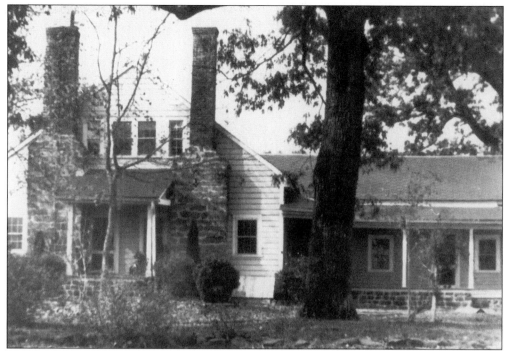

The Richard Leigh home at Leigh Farm in southern Durham County is pictured here *c.* 1930. Quick action in 1974 by Curtis Booker, a Leigh descendant, saved the 1830s plantation complex from being paved under Interstate 40. (Courtesy Curtis Booker.)

At the other end of Durham County, Stagville became the first project of the Historic Preservation Society of Durham in 1974. The antebellum plantation became a state-owned center for teaching historic preservation technology. (Courtesy Historic Stagville.)

Restoring Stagville's 18th-century homeplace was not without its hazards. The chimney was inhabited by a colony of bees, which had to be persuaded to move outside before work could proceed. (Courtesy Historic Stagville.)

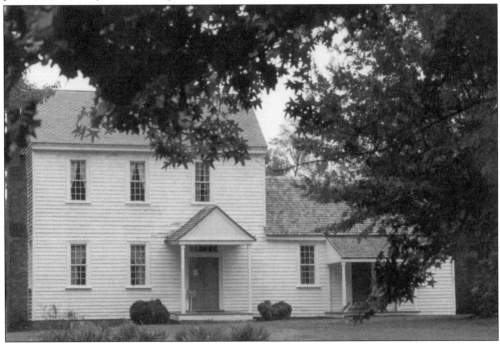

The Bennehan House today sports fresh paint and a new cedar-shingle roof on its 1780s original section. The larger part of the house, at left, was added in 1799.

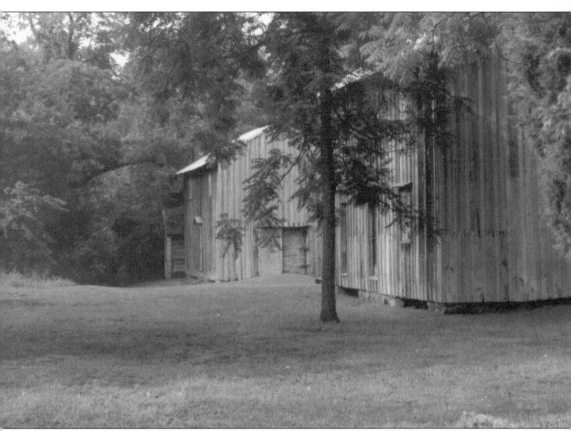

These slave cabins are located at Horton Grove, near the upscale Treyburn development in northern Durham County. One of several slave villages that once stood at the vast Stagville plantation complex, Horton Grove was occupied by slave descendants well into the 20th century.

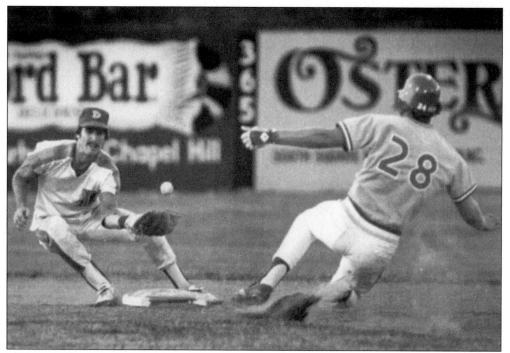

Durham Bulls second baseman Phil Lunsford tries to make a play in the team's born-again 1980 season at the Durham Athletic Park. He dropped the ball, but the team was a hit. (Jim Thornton photo courtesy the *Herald-Sun*.)

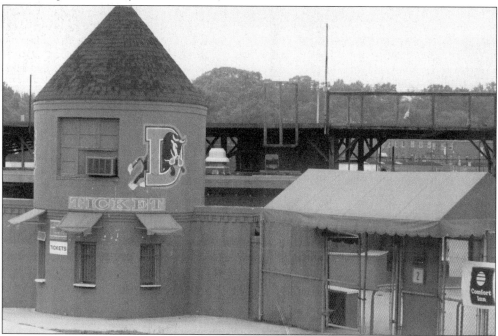

Abandoned by baseball for almost a decade, the 1939 Durham Athletic Park, just north of downtown, became a focal point of community spirit with the rebirth of the Durham Bulls baseball team in 1980.

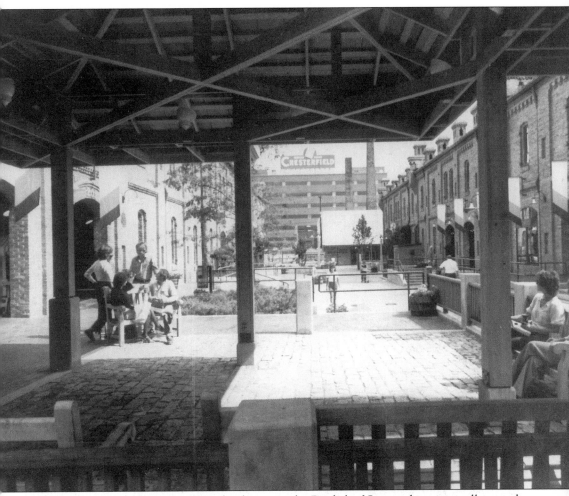

Emblematic of Durham's reclaiming of its heritage, the Brightleaf Square shopping mall opened in the fall of 1981. Turning two old tobacco warehouses into trendy retail space, Brightleaf became a visitor attraction in its own right, as well as an example of what could be done to revive run-down urban areas. The courtyard, seen above, was the venue for the Durham Arts Council's 1985 production of *Carmen*—on opening night of which, the "Toreador's Song" was rudely interrupted by the horn of a passing train. (Courtesy Duke Homestead State Historic Site.)

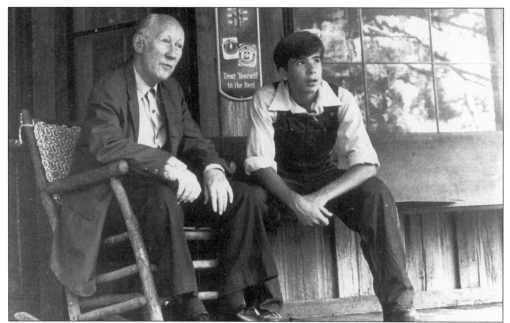

University of North Carolina journalism professor Walter Spearman, playing a Civil War veteran, talks to young Derek Peterson, playing Durham County farm boy Tommy Clement in *Carolina Bright*. The movie was produced in 1980 by the North Carolina Department of Cultural Resources and serves as an introduction for visitors to the Duke Homestead State Historic Site and Tobacco Museum. (Courtesy Duke Homestead State Historic Site.)

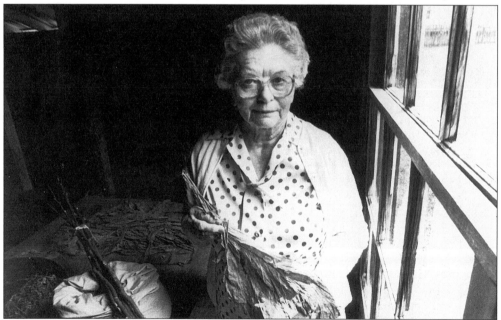

Mildred Harris grew up on a tobacco farm in northern Durham County and gave years of service teaching visitors about the golden leaf at Duke Homestead. "She is absolutely the apex of history for Durham County," said Ed Cooke, a member of the County Preservation Commission, when Harris died in 1989. (Courtesy Duke Homestead State Historic Site.)

Emory F. "Pap" Parker became a historical interpreter at Duke Homestead after retiring from Liggett & Myers and being told by a friend, "You love to talk so much you ought to work at Duke Homestead." He liked it so much, he also volunteered at West Point on the Eno and Bennett Place. "He was a natural-born comedian, had a joke for any occasion," says Duke Homestead manager Dale Coats. (Courtesy Duke Homestead State Historic Site.)

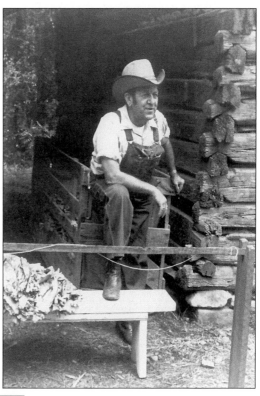

The late Mary and George Pyne were custodians of Durham's heritage. (Courtesy Milo Pyne.)

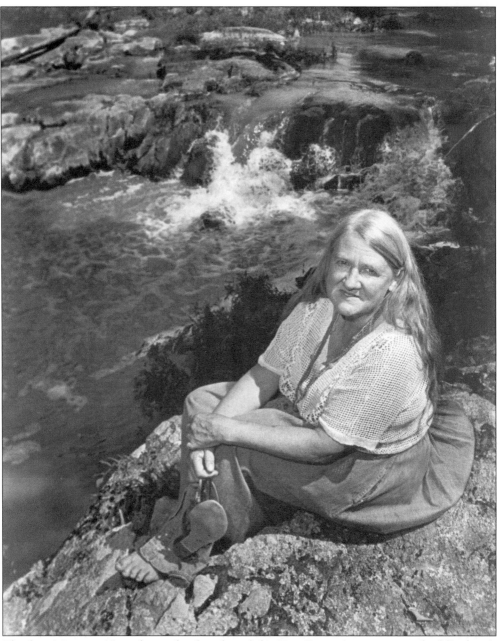

The late Margaret Nygard was the founder of the Eno River Association and of Durham's historical and environmental conscience. (Courtesy the *Herald-Sun*.)

Seven
PROMISES
AND REMINDERS

From back country to whistle stop to mill town to high-tech center, Durham city and county have changed over and again. Here and there, traces remain (some almost hidden by weeds and kudzu) of the way things have been and hints of shapes of things to come—maybe to come, that is.

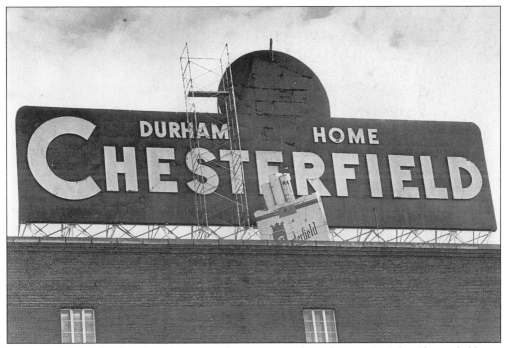

For years, it was a landmark looking over downtown Durham, but in 1986 the Chesterfield sign came down from the top of the Liggett & Myers factory, replaced by a corporate billboard devoid of personality. (Jim Sparks photo courtesy the *Herald-Sun*.)

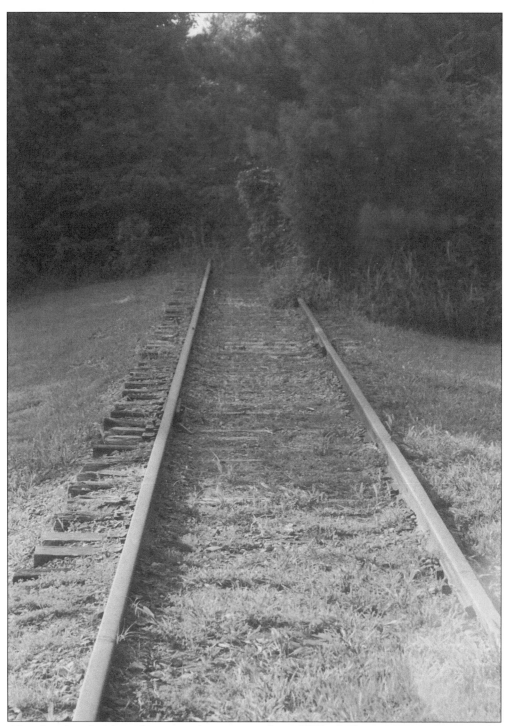

Abandoned railroad tracks run only into woods at Willardville, once a station on the Lynchburg & Durham line near Orange Factory. The rusting tracks are one of the silent reminders that remain of a Durham County past that is rapidly being lost, forgotten, and paved over.

Built in 1860, this monumental barn at Stagville is testimony to the confidence that Southern planters felt in their future even on the verge of the War between the States.

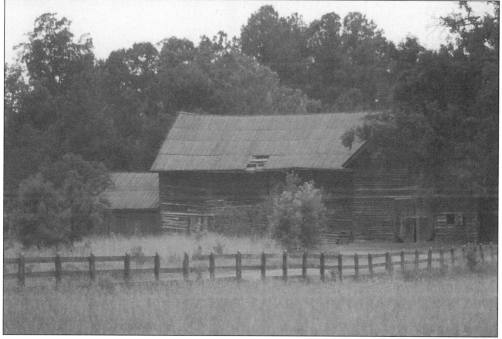

In the southwestern corner of Durham County, this barn was part of the cotton complex of Fendal Southerland. Retired as an overseer at Stagville, Southerland bought property near New Hope Creek, from which he could likely have watched the last combat of the Civil War in North Carolina along present Stagecoach Road. A reversal in the cotton market proved Southerland's undoing; he hanged himself in the barn on Jan. 22, 1878.

The Arrowhead Inn is a bed and breakfast hostelry opened in 1985 in an 18th-century residence, shaded by 150-year-old magnolias, along the Trading Path—a trail originally made by Native Americans and later used by European settlers, running from the James River in Virginia to the Savannah River near present Augusta, Georgia.

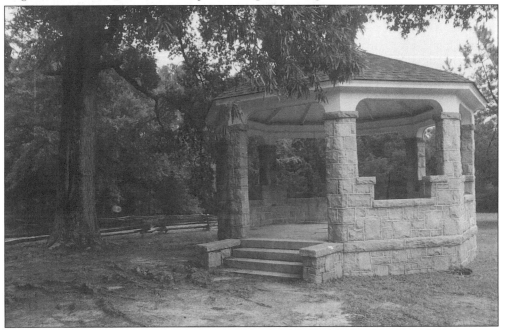

This stone gazebo that now stands at Bennett Place originally stood at Rotary Park, downtown, near the old Academy of Music. It was moved to make way for the downtown hotel in 1924.

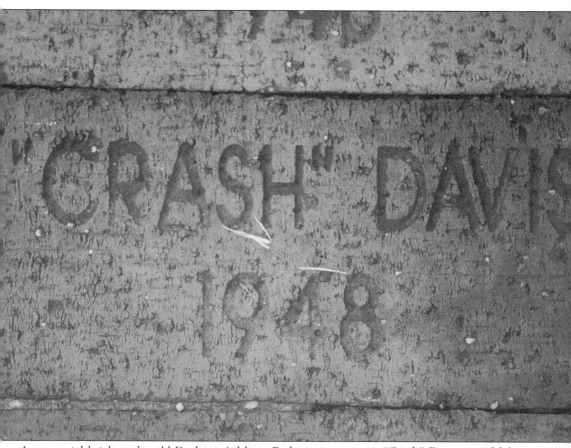

A memorial brick at the old Durham Athletic Park commemorates "Crash" Davis, a real-life Durham Bull whose name was adopted for the Kevin Costner character in the 1988 movie "Bull Durham."

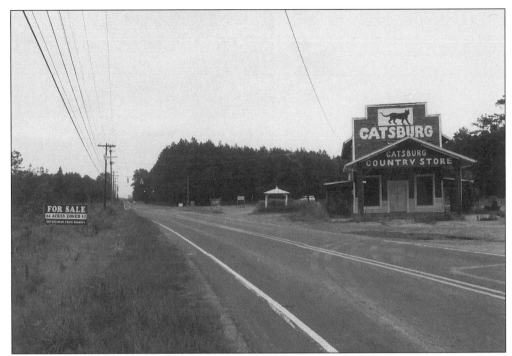

Catsburg Country Store on the Old Oxford Highway. Once a railroad crossing, complete with a ghost train, the area got its name from longtime Durham County sheriff "Cat" Belvin, who lived nearby. Belvin got his nickname for his ability to move with silence and stealth, a handy quality for a lawman who needed to slip up on moonshiners.

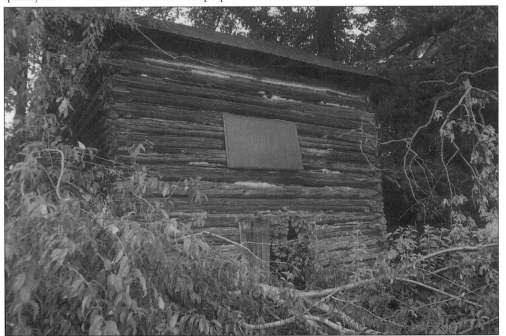

The elements have already all but obliterated the Pepsi-Cola sign and, in their patient way, are overwhelming this log tobacco barn near Bahama.

The Liberty is the last remaining warehouse of Durham's one-time "Tobacco Row" on Riggsbe Avenue. Once upon a time a virtual carnival that lasted from late summer almost until Thanksgiving, Durham's tobacco market heard its last auctioneer in 1987.

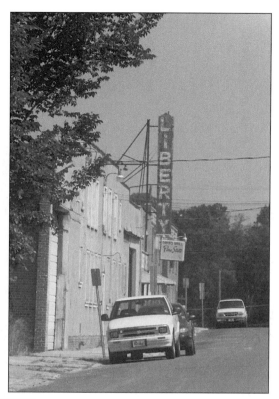

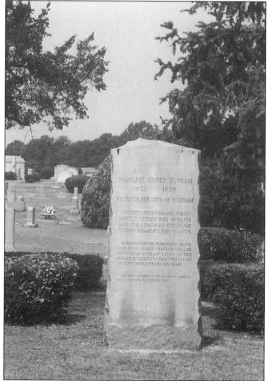

Dr. Bartlett Durham, who gave 4 acres to the North Carolina Railroad for a depot and his name to the town that grew up around it, rests in a grassy knoll at Durham's Maplewood Cemetery. The marker, placed after his body was relocated from a family burying ground west of Chapel Hill, has three facts wrong. Durham was born in 1824, not 1822; he died in 1859, not 1858; and his middle name was "Leonidas," not "Snipes."

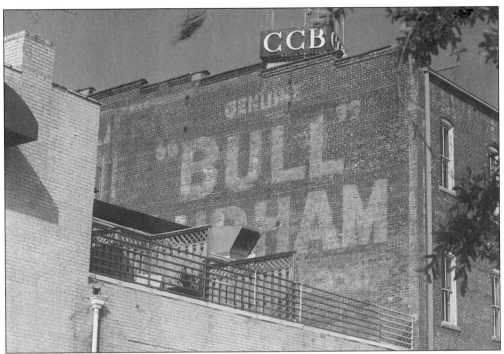

Sign of the times gone by: a Bull Durham tobacco advertisement still graces the side of a building in downtown Durham.

Sign of the times to come: the revitalization of downtown Durham has been promised for 40 years, but kudzu grows faster than bright—even brightleaf—ideas.

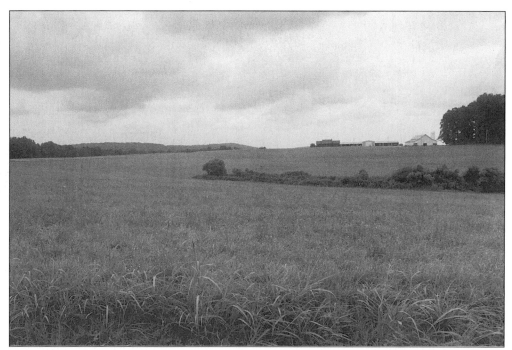

Even today, Durham County remains a crossroads of past and future. In the north, bucolic landscapes such as this, near Quail Roost, still typify the county.

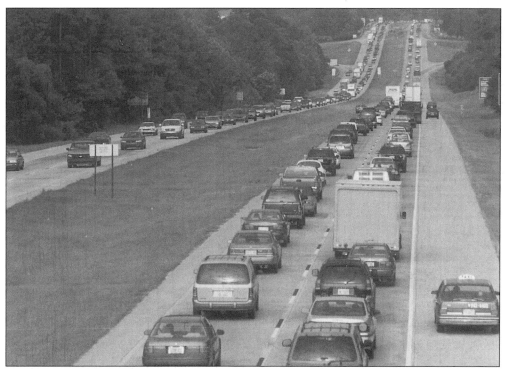

While in the south, such as this stretch of Interstate 40 east of Barbee Road, urban sprawl has become a way of life.

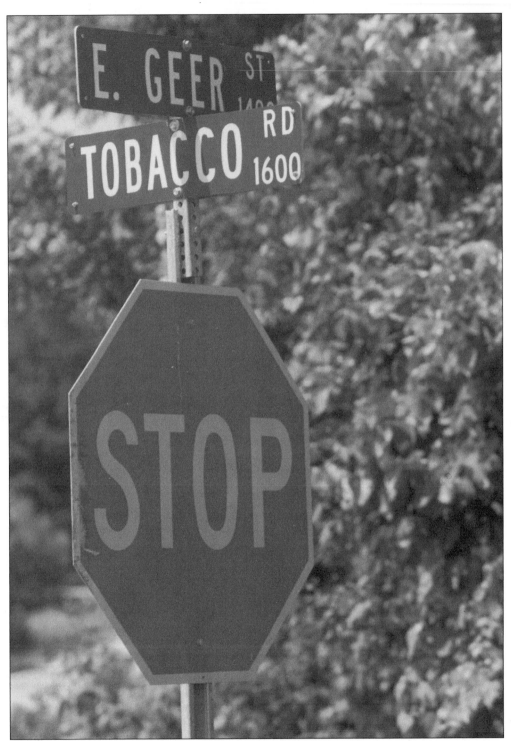

One thing is for sure, Durham as a tobacco town is history. The last tobacco auctions in Durham were held at the Planter's Warehouse off East Geer Street in 1987. The name "Tobacco Road" today seems quaintly out of place.